AUBREY BEARDSLEY

A SLAVE TO BEAUTY

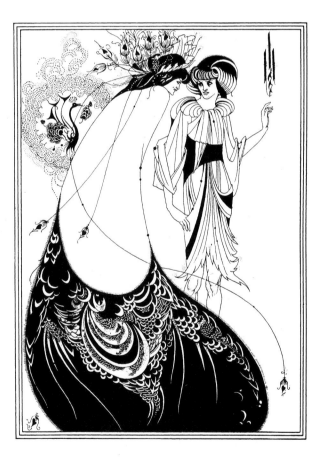

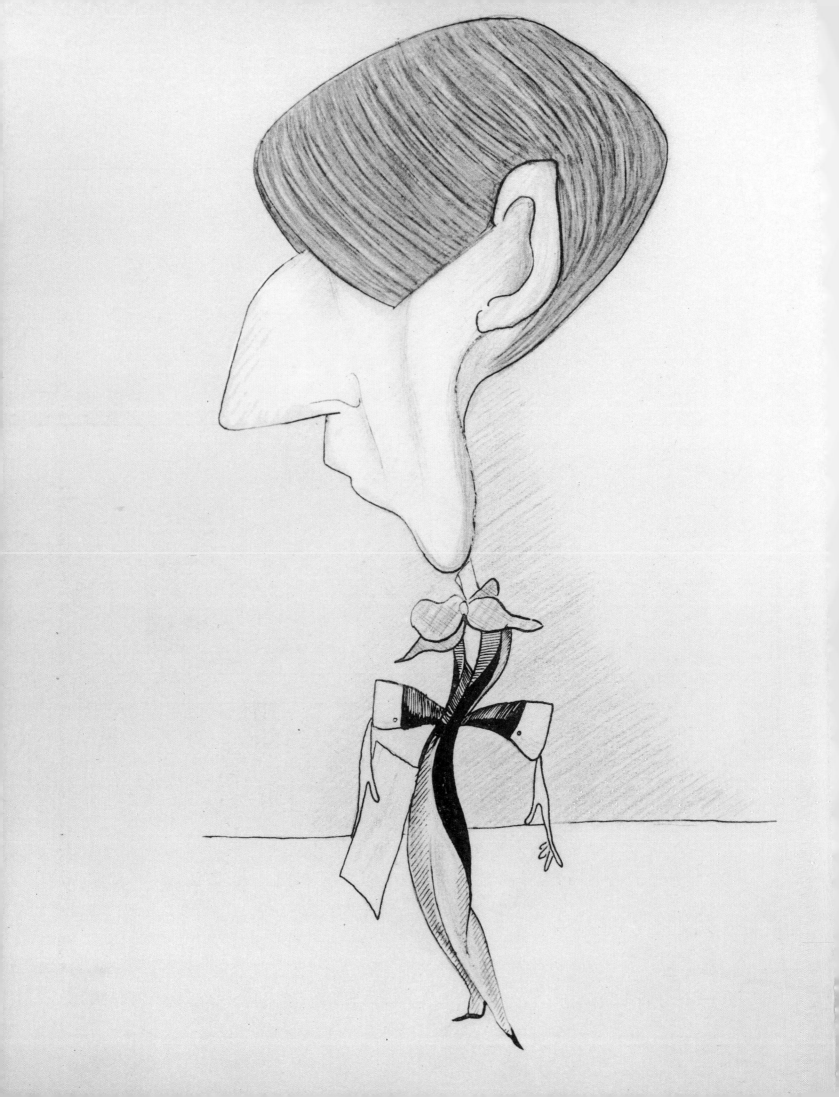

AUBREY BEARDSLEY

A SLAVE TO BEAUTY

David Colvin

ORION

For Henrietta

ACKNOWLEDGEMENTS

I would like to thank Stephen Calloway, who was, even more than usual, quite self-less in the help, advice and support he offered, besides allowing me unfettered access to the unpublished papers of Professor von Frieblisch; Nick and Rachel Lane Fox, for their generous hospitality; my father, who cast his steely eye over the manuscript; Andrew Best, who let me off from time to time; Lawrence Mynott, who made several valuable suggestions; Tom Graves, who again found such delightful pictures; and Trevor Dolby, who lurked behind every scene.

Unless otherwise indicated, illustrations have been provided by private collections and the Weidenfeld and Nicolson Archive. Page 2: Beardsley by Max Beerbohm. (Private Collection/Courtesy Eva Reichmann)

First published in 1998 by Orion Media
Am imprint of Orion Books Ltd
Orion House, 5 Upper St Martin's Lane,
London WC2H 9EA

A CIP catalogue record for this book is available from the British Library.

ISBN 0-75281-784-1

Designed by Briony Chappell
Reproduction by Pixel Colour Ltd, London
Printed in Italy

CONTENTS

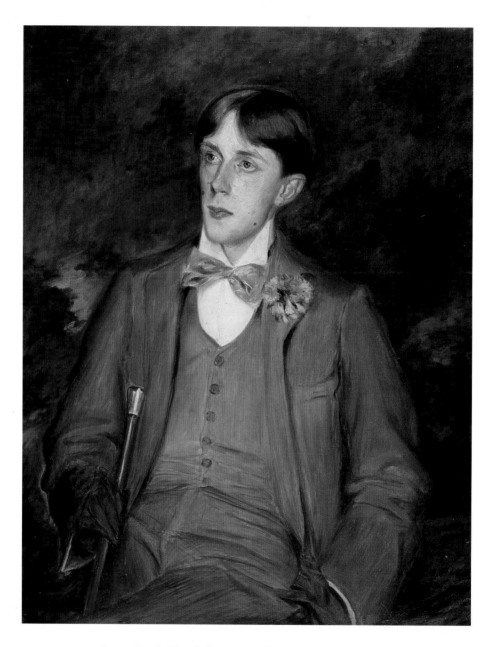

*Jaques-Emile Blanche's portrait of Aubrey Beardsley, his face
'like a silver hatchet'. (National Portrait Gallery /
©ADAGP, Paris and DACS, London, 1998)*

1

'I OFTEN DO LITTLE DRAWINGS'

It is unlikely that Aubrey Beardsley's great-grandfather Thomas Pitt, a surgeon who had settled in Brighton during the seaside town's Regency vogue, was a scion of the Chatham Pitts, although Aubrey himself was often pleased to claim descent from the great Georgian dynasty. Thomas Pitt's son William, born in the year of Waterloo, trained, like his father, as a doctor, spending most of his career in the East, in the employ of the Indian Medical Service. After twenty years' service, he retired with a good pension and the rank of Surgeon-Major.

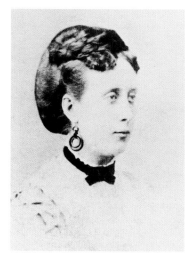

The second of William's three daughters, Aubrey's mother Ellen Agnus, was a belle known to Brighton, it is said on account of her slim beauty, as 'the Bottomless Pitt'. Born in Bengal in 1846, she returned to Brighton with her family, after a brief interlude in Jersey, in 1859. Having received a thorough education in music and literature from her mother, and being accustomed to the rarefied life of the expatriate, the haughty and spirited Ellen settled unquietly into the more serene life of the Sussex town. By her own account, her behaviour often gave cause for 'scandal-mongering' among her circle, for she was lively, intelligent, and possessed of an indomitable nature – one which was to be fully tested by the trials of her life.

When he met his future wife, Vincent Paul Beardsley was thirty-one years old: beyond that, and the barest facts of his life and death, almost nothing is known about him. This 'shadowy figure, stealthy as a phantom in Victorian carpet slippers', certainly did not pretend, as the Pitts did, to any distinguished lineage.

He was the only child of Paul Beardsley, a tubercular Clerkenwell goldsmith who had died in 1845, when the boy was only five or six years old. On the income from a quarter share of his grandfather's estate, which included some property on the Euston Road, and a small sum of money left by his father, Vincent contrived to live as a 'gentleman'.

Although he himself lived to be seventy, Vincent was, like his father, tubercular, and it was probably for the sake of his health that he came from time to time to take Brighton's supposedly health-giving air. It was on the seafront during one such visit, in the summer of 1870, that he met the twenty-four-year-old Ellen. Vincent, with his London manners, bristling moustaches and air of wealth, and

TOP *Ellen Beardsley in the mid-1870s.*

ABOVE *Vincent Beardsley, also in the mid-1870s. He was to prove a great disappointment to his wife and family.*

RIGHT The Seafront, Brighton, *in the mid-1800s, by Frederick Nash, (1782–1856). (The Bridgeman Art Library / The Fine Art Society, London)*

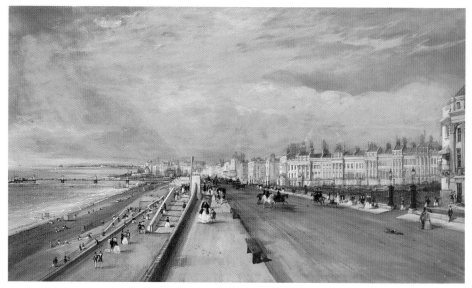

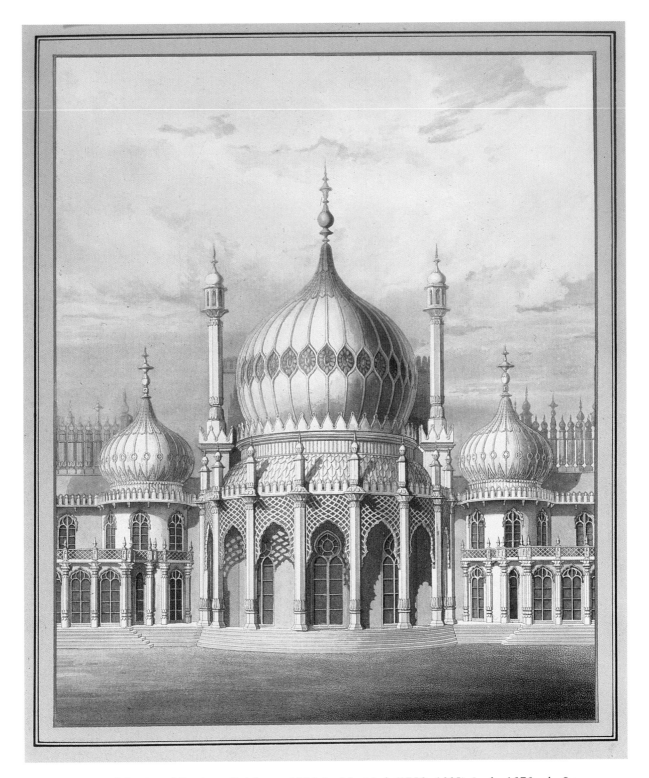

View of the Royal Pavilion, Brighton, *1826, by John Nash (1752–1835). In the 1870s, the Prince Regent's magnificent pleasure-dome was, after decades of neglect, being restored to its former glory, and proving an attraction for locals and visitors alike. (The Stapleton Collection / The Bridgeman Art Library)*

Ellen, pert, vivacious, and unconventional, were immediately attracted to each other. Their courtship had to be conducted in secret: in those days, even to speak to a stranger without a formal introduction was considered scandalous. Clandestinely they met, on the Pier and in the gardens of Brighton Pavilion, the magnificent rococo pleasure-dome of the Prince Regent. It was not long before Vincent proposed, and Ellen had no hesitation in accepting him.

On 12 October 1870, from Ellen's family house in Buckingham Road, Vincent and Ellen set out to be married at the Church of St Nicholas of Myra, Brighton. There was a heavy autumn storm blowing, and the weather became so bad that the bridal party was forced to enter the church through the church vestry to avoid a soaking. Such a day did not augur well for a happy marriage: indeed it began with disaster.

While they were still on their honeymoon, Vincent was threatened by the widow of a local clergyman with a lawsuit for breach of promise. The Pitt family obliged their son-in-law to settle the case quietly, without public scandal, and Beardsley had to sell his London property. The loss of the income meant that he would now have to do what he was quite unsuited for – earn a living.

Over the years, Vincent would hold a variety of clerical positions, employed for the most part by London breweries, although he was once engaged by the West India and Panama Telegraph Company. These were undemanding, if unlucrative, jobs which kept him busy enough. Despite the loss of his private means, relations between the new Mr and Mrs Beardsley continued to be cordial. There remained enough capital for Ellen herself not to be obliged to work, and the couple took lodgings in London. Ellen returned to her family home, however, when she

Aubrey and Mabel, in around 1875. The two children remained close throughout their lives.

became pregnant at the end of the year, and on 24 August 1871, she bore her first child, Mabel. Almost exactly twelve months later, on 21 August 1872, she gave birth to her second, Aubrey Vincent.

Having contracted a puerperal fever during Aubrey's birth, Ellen remained confined to bed for several months. When she finally recovered, it was to be greeted with the news, long withheld in view of her illness, that Vincent had, in some disastrous scheme, lost what was left of his patrimony. It was a heavy blow, for it meant that Ellen, now, would also have to go out to work. Relations between the two were irreparably damaged, and from this time, Vincent Beardsley drops out of the focus, even the

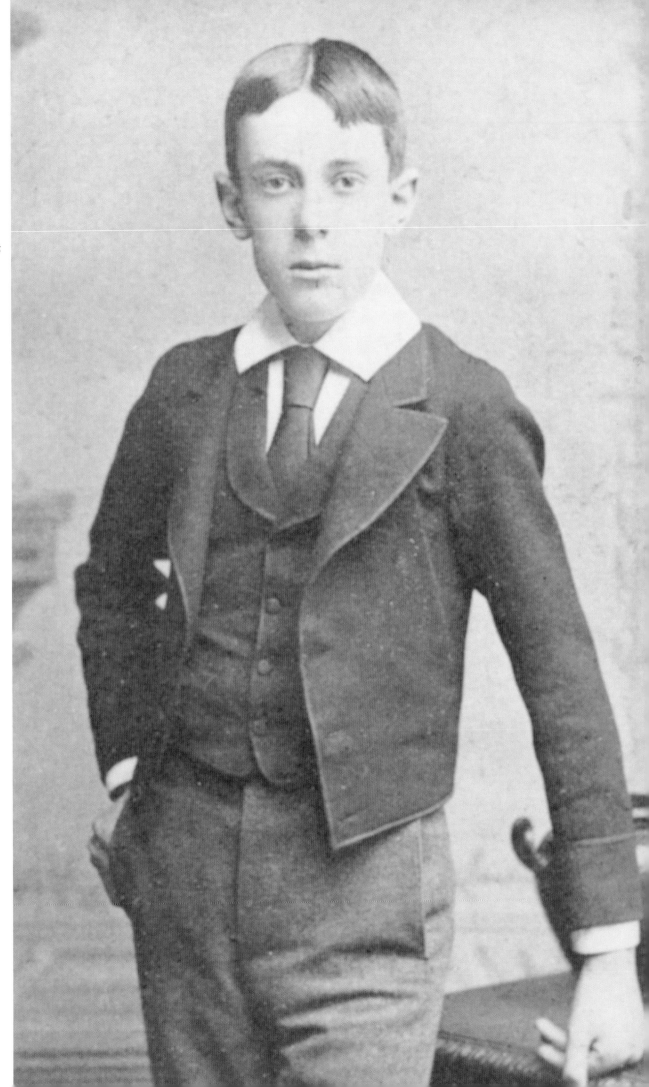

Aubrey Beardsley,
aged about thirteen.
'A quiet, reserved child',
his self-possession and
confidence was apparent
from the earliest days.

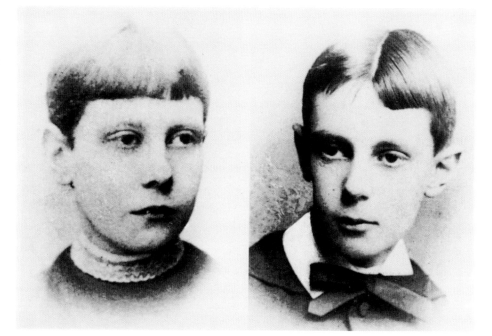

Photographs of Mabel and Aubrey in the early 1880s. Both children were educated in music and reading by their mother.

Aubrey's first commissioned work, a drawing which evidently owes much to the sugared illustrations of Kate Greenaway.

frame, of the Beardsleys' family life, henceforward to be heard of so rarely and incidentally that many of Aubrey's friends in later life assumed that Mrs Beardsley was a widow.

One may only hope that Ellen exaggerated the poverty under which her family laboured when she claimed to 'work all day on a penny bun and a glass of milk before coming home to look after the children'. Vincent was at best irregular about providing his family with money, and Ellen took a number of positions, as both a governess and a teacher of music and reading, to support them. In view of her good education and the strong vein of didacticism in her nature, she was ideally suited to such work, however much she chafed at it.

The education of her own children, meanwhile, was certainly not neglected. Every evening she performed for them a little concert of six short piano pieces, carefully selected and regularly rotated so that 'they did not hear the same thing too often. I would not let them hear rubbish.' She took equal care over their reading: 'It was the same with books. I would not let them read rubbish.' By the age of six, Mabel had read Walter Scott and Charles Dickens, and was able to recite 'from *Pickwick* for two hours on end'. She had a will of her own nevertheless, and Ellen's attempts to force Thomas Carlyle on her daughter were met by obdurate refusal.

The little Aubrey was from the earliest age a frail creature, and although Ellen was careful not to spoil or favour either child, her son was particularly precious to her, 'like

a delicate piece of Dresden china'. She discerned in him precocious talent, in particular a gift for music, and had him playing Chopin 'as charmingly as anyone could wish' even before he was old enough for school.

When he was seven the first signs that Aubrey might have inherited his father's tuberculosis appeared. As a pre-emptive measure, in October 1879 Ellen sent him from the smoke and pollution of the capital to Hamilton Lodge, a boarding school near Brighton where the boy was to spend two happy years. Although he missed his sister, and his letters are full of enquiries after her activities, he seems to have enjoyed the freedom and independence of life away from the pressure of his mother's expectations. The regime was relaxed: a sunny day was more than likely to be declared a holiday, and the boys were taken on regular jaunts to local circuses, concerts, fêtes and bazaars or other amusements. He got on well with the other children, and liked being taught by people who were not as demanding of him as his mother had been.

Even at such a tender age, in his letters home Aubrey always took particular trouble to reassure his mother that he was strong and healthy, but in 1881 his tubercular symptoms reappeared and could not be ignored. Ellen took him out of school and moved the family to Epsom, to help her precious boy 'to get strong'. They stayed there for two years, until, in about 1883, financial pressures forced her to return to work in London.

Like any other child Aubrey delighted in drawing. Around this time, he received his first 'commission', from Lady Henrietta Pelham, a family acquaintance who had 'admired his little pictures very much'. In an elaborate act of charity, she gave the young boy some illustrated books to copy from, and offered to pay thirty pounds for Aubrey to design the place cards and

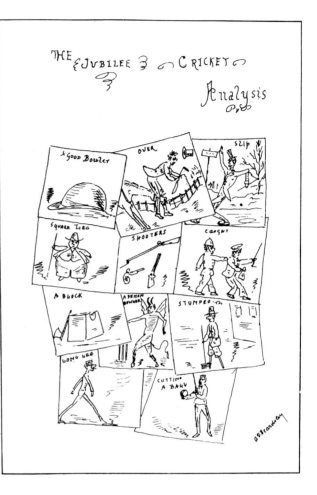

The Jubilee Cricket Analysis, *Beardsley's first published drawing, from Brighton Grammar School's magazine* Past and Present.

menus for an impending family wedding. As ever, Aubrey jumped at the chance to, in his mother's words, 'shine'.

After his death Ellen would be disparaging about these drawings, saying that they were 'the only un-original work he ever did in his life', but the money must surely have been useful, and Aubrey himself was delighted by his success. In a letter to his new patron, having modestly disparaged his copy-work, he added, 'I often do little drawings from my own imagination,' and offered to make her new pictures whenever she

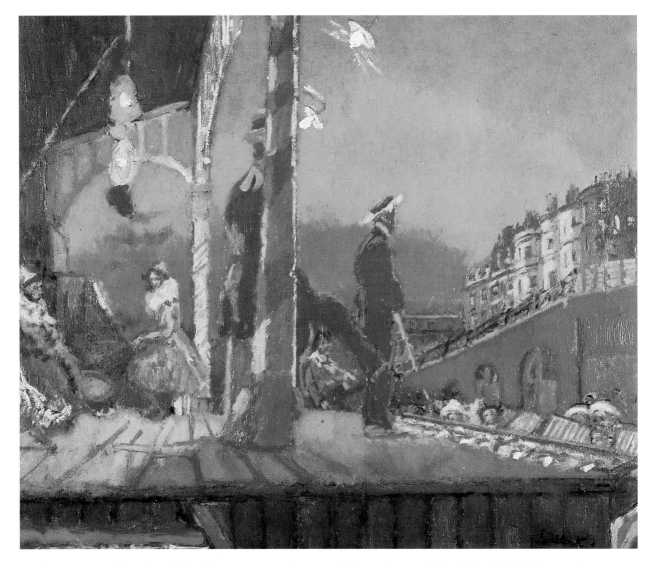

Brighton Pierrots, *by Walter Sickert. The tragi-comic character of Pierrot fascinated Beardsley. (The Bridgeman Art Library / The Fine Art Society, London / © Estate of Walter Richard Sickert. All Rights Reserved, DACS, London 1998)*

liked. A second commission did not, however, follow.

Money continued to be in short supply, and although she was to survive both her children, Ellen was frequently ill. In the summer of 1884, Mabel and Aubrey were sent back to Brighton, to live with Sarah Pitt, their mother's 'strange old aunt', a sixty-nine-year-old spinster who entertained 'peculiar notions about children'. She kept no toys in the house, and only one book: a *Short History of England*. If, in Ellen's

opinion, the children were prodigious geniuses, Aunt Sarah 'pretended they were backward'. When Vincent visited one afternoon he found them 'sitting patiently on high-backed chairs' in the hall, with nothing to do. Objecting that 'the children can't be happy like that,' he was told that they were, on the contrary, 'as happy as birds'. Vincent retorted 'All I can say is that they must have damned contented minds.'

Sarah Pitt must have known that such a life was

unsuitable for her sensitive nephew, however 'backward' she thought him, and after four months of this life she agreed to pay for Aubrey to attend the Brighton Grammar School, as a day-boy. Beardsley was miserable at first; he missed his sister and was frightened by the strangeness of being away from the bosom of his family. In his first term he was proud, lonely and homesick, and kept himself apart from his fellows, acquiring the nickname of 'Shakespeare' for what his fellows misinterpreted as a studious nature. In the spring term, when he became a boarder, Aubrey's liking for the place improved. He had discovered that his drawing, far from being a solitary activity, could win him respect, and took to producing wickedly funny caricatures of the masters for the amusement of his comrades.

Never academically interested, he did badly at mathematics and spelling in his classification exams, and despite his vociferous protests that an ability to count was unnecessary so long as one had enough money *to* count, Beardsley was moved down a year. Complaining bitterly about the injustice and 'absurdity of a person of his mature years being placed in classes with babies to learn such unimportant skills', he was in the middle of a long and impassioned disquisition on the iniquity of his position to an attentive gathering in the playground, when his housemaster, Arthur King, discovered him, and sent Aubrey to his study to await punishment. A. W. King was a keen producer of amateur theatricals, and Beardsley's dramatic display had amused him.

Having given the boy a nominal punishment, King took a personal interest in Aubrey's education. Realizing that the boy was too delicate for the rough and tumble of games and swimming, King instead gave Beardsley the run of his private library, while at the same time encouraging him to 'use your talents to

amuse and instruct… instead of giving annoyance to your victims by these innumerable sketches.' Already well versed in Shakespeare, Beardsley's horizons expanded to encompass Restoration and Georgian playwrights, poets such as Swift and Byron, and historians and novelists such as Carlyle and Thackeray. With this new perspective, Aubrey now dismissed Dickens, whom he had been taught at his mother's knee to revere, as little more than a 'cockney Shakespeare'.

He made some firm friendships. With George Scotson-Clark, 'a strange, impressive youth' with a tastes in art well advanced for his years, Beardsley started to look at pictures and listen to music from a wide range of traditions; from Charles Cochran, later the world-famous impresario of 'Cochran's Young Ladies', Aubrey's interest in drama developed into a practical, not merely intellectual, passion. Scotson-Clark, as a day-boy, came low down in the hierarchy of the school; Cochran had come to Brighton Grammar only after being expelled from his last school for rowdiness: each, in his way, an outsider, the three boys became an inseparable triumvirate. As often as they could raise the funds they stole off to matinées in Brighton, and with the full support and encouragement of A. W. King, they mounted regular concerts, playlets and performances in the school.

Beardsley's personality flourished. His formerly withdrawn nature and stoic patience were transformed into a taste for high spirits and practical jokes. He wrote musical *compositions* – none has survived – poems and *conversazioni,* and, as King had suggested, he started to make more concerted attempts at drawing, which the school magazine published from time to time.

But the halcyon days of childhood were not to last. Whether owing to lack of funds, or just because he was not an academic success ('he never did much work,' his

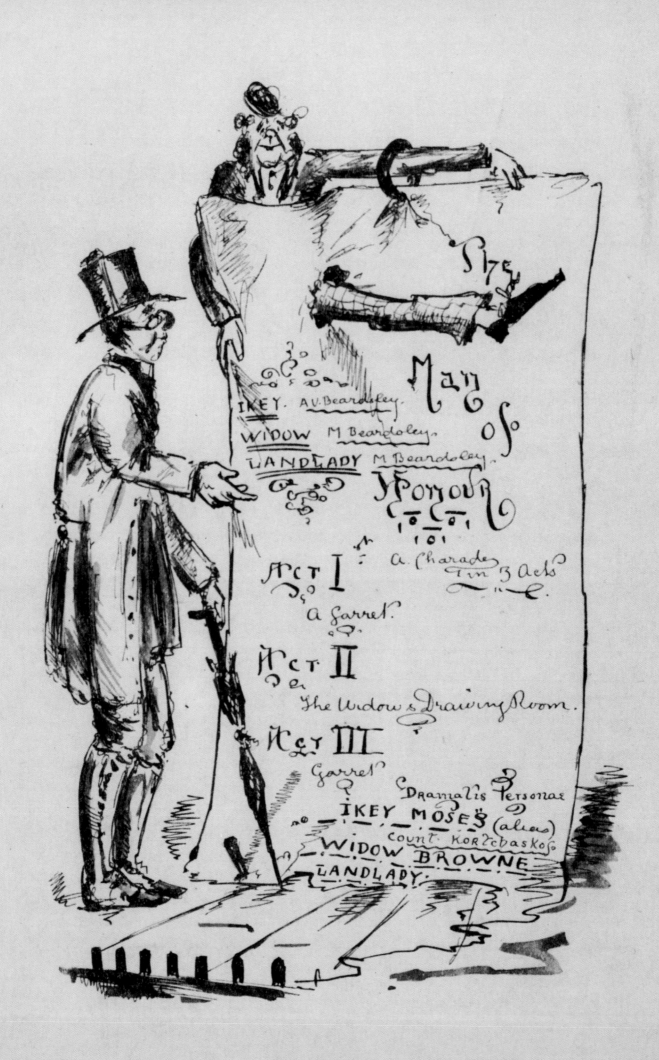

At the Theatre, *water-colour by Steven Spurrier (1878–1961). Encouraged by his housemaster, Aubrey made frequent visits to the theatre. (The Bridgeman Art Library / Phillips, The International Fine Art Auctioneers)*

LEFT *One of Beardsley's many programme designs for the 'Cambridge Theatre of Varieties'.*

mother said), after three very happy years Aubrey left Brighton Grammar School after the winter term of 1888, moving to London to live with his parents. In January 1889 he began work as a ledger clerk at the offices of the Islington District Surveyor in Wilmington Square.

Consigned to a desk at the office of an Islington architect, with scant education behind him, and apparently no glorious future in front, there was little to distinguish Aubrey Beardsley from his fellow clerks. Thousands upon thousands of young men in his same position passed their waking hours at nothing more than copying slips of paper into great ledgers all day, every day.

He was to remain a clerk for another three and a half years. Though still fired with a passionate interest in art and literature, he was not – not yet – an artist. No scholar – even his staunchest ally, Mr King, had not fought to keep him at school – and without either prospects or contacts, Beardsley himself seemed resigned to, if not overly content with, his lot. When, early in 1889, he wrote to King about his activities in London, all he could say about his job was that 'I don't exactly

dislike it, but am not (as yet) frantically attached.' It seems clear that, for the present, the boy Aubrey had no inkling of the promise which slumbered within him, nor of the destiny which he was to go on to forge for himself.

The first lodgings taken by the family were at 32 Cambridge Street, a quiet and sheltered Pimlico road. In those cramped quarters, Mabel and he invented 'The Cambridge Theatre of Varieties', a fantasy drawing-room theatre for which they mounted short musical and dramatic presentations for the family. Aubrey designed the 'programmes' – full of charming, characteristic vignettes, thumbnail sketches and self-caricatures – and the children took turns at performing music-hall ditties such as *The Little Stowaway* and *The Legend Beautiful* for curtain-raisers, followed by single-act farces of the day such as *Box and Cox* or Charles Brookfield's *Nearly Seven*.

These entertainments kept alive their dreams and ambitions. Mabel, who had been forced through lack of money to turn down a scholarship to Cambridge, could dream of being an actress; Aubrey, who thought that he wanted to be a writer, maintained his interest in drawing at a time when there was no other stimulus to do so. Despite Vincent's periodic disgraces and the thousand disappointments of the family's relative poverty, there must have been a relaxed and happy atmosphere in that small house, to allow two imaginative children to lavish such care and time over their 'shows'.

Head of Balzac, *1896. Balzac's indefatigable industry and breadth of imagination was very like Beardsley's own.*

At some point in the middle of 1889, a long-promised clerical position in the City became vacant, and Beardsley became an employee of the Guardian Life and Fire Assurance Company at Lombard Street. Life in London at this time was not without its little pleasures in compensation for the drudgery of its chores. No longer, as he and Cochran had had to at Brighton, was Aubrey obliged to invent money-raising schemes: his annual salary of about fifty pounds, even after an allotment to his mother for his upkeep, allowed him spending money. He went, as often as his funds allowed, to the theatre or to musical concerts, waxing lyrical about the 'splendid' Henry Irving and Ellen Terry in *Macbeth*. And as time went on he nurtured his love of music, and the operas of Wagner in particular.

Most importantly, there were bookshops, those warehouses of dreams where Aubrey could spend endless hours browsing through volumes old and new, occasionally buying books to add to his own developing collection. His library reveals a wide range of purchases made at this time: he developed a particular love for French novels, especially those of Balzac, and for the Play, as he embarked upon a characteristically idiosyncratic study of English drama, buying each volume of the Mermaid series as it was published, and making copious notes in their narrow margins.

Late in the year, as autumn turned to winter and the cold crept into his lungs, over-exertion and London's dreadful pollution caused the first serious

haemorrhages Beardsley had suffered in years. The family sought out Dr Symes Thompson, a leading specialist in tubercular diseases. Thompson did not initially diagnose tuberculosis, merely a heart 'so weak that the least exertion brings on a bad haemorrhage'. If time proved him to have been mistaken, the mis-diagnosis was no tragedy: doctors in those days could do little to combat either malady, except confine the patient to the strictest bed-rest. Beardsley left his job, and settled down to the tedious life of an invalid. That Christmas, he was 'kept on slops and over basins', initially in fear of his life, but then, slowly, recovering.

While ploughing through his Balzac and his Molière, until, as he reported to King, he could 'read French almost as easily as English', to occupy the time during his long convalescence Beardsley was inspired to turn his own hand to literature. His efforts paid off when *Tit-Bits* magazine, a species of *Readers' Digest* of the day, published a little story of his, 'A Confession Album' in its issue of 4 January 1890. It earned the magnificent sum of £1.10.0. This slight fantasy about a young man who loses his fiancée through an ill-judged spark of wit is not, by any stretch of the imagination, great literature, yet it stands in sprightly contrast to the article, entitled 'How Four Hundred tons of Fish Come to London Daily', printed next to it.

It is a testimony to the boy's charm that when, by the summer of 1890, after six wearying months of inactivity, Aubrey was again well enough to return to work, the Guardian office happily welcomed him back to his old job, with the increased salary of seventy pounds. Since Mabel was also at work – as a teacher – the family could now afford more spacious apartments. In June they moved just round the corner, to 59 Charlwood Street, a house which they shared with

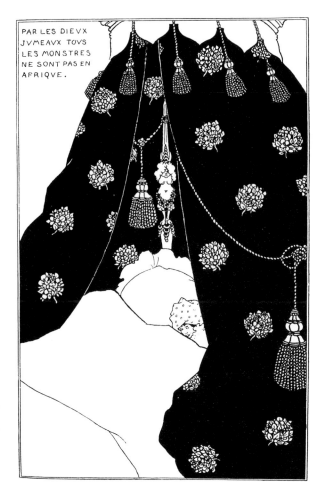

Portrait of Himself, *1894. A cloven-footed herm watches over Aubrey's sleeping figure.*

just one other family. They were even able to afford that necessary luxury of bourgeois life, a live-in maid.

To be a published author was Beardsley's first hint of the 'oof and fame' (as he called it) which, even among his own narrow circle, he was already craving. Cochran, still at Brighton, took him seriously enough to 'commission' a one-act farce, to be performed at a reunion of the Brighton Grammar School Old Boys' Association. With Cochran and Scotson-Clark in the leading roles, Beardsley's *A Brown Study* was performed 'with some success' at the Brighton Pavilion

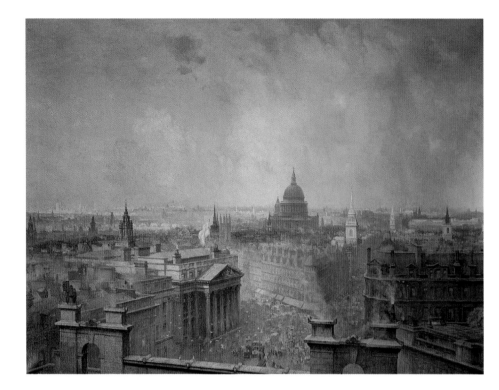

The Heart of the Empire,
by Niels Moiler Lund
(1863–1916): the City
of London as Aubrey would
have known it.
(The Bridgeman Art
Library / Guildhall
Art Gallery, Corporation
of London)

in November 1890. Six months later, he was still boasting of the triumph.

The Square Mile was a thriving place, the hub of the Empire and the world's trade, full of life and its accidents, of people and their passions. Office hours were not punishing, even by today's easier standards: clerks worked from 9.30 until 5.30, and governed by their petty rules and arcane routines, Beardsley's days in the City would have been no less dry or mundane than they had been at the Islington surveyor's. He quickly made a reputation for himself as the office 'wit'. Just as they had at school, his caricatures and thumbnail sketches provided amusement for his colleagues, and earned for Beardsley their affection and respect.

But where he had once been content to bide his time, Aubrey had received an intimation of his mortality. A sense of ambition, and of urgency, had crept into his soul while he had lain gasping for breath. When he returned to health, he began to make a serious effort to expand the boundaries of his experience and knowledge. Now he drew constantly, usually in the evenings, after work and theatre or concerts. His weekends were spent at the Print Room of the British Museum, poring over old drawings; in the National Gallery, where he built up an astoundingly thorough knowledge of the collections; or at the various private art galleries that dotted the West End.

His critics, even those who are in every other respect his fierce partisans, have often decried the artistic poverty of Aubrey's juvenile drawings — even, in some

cases, to the point of wishing that the few which survive had been destroyed. 'His *juvenilia* are as mediocre as his *puerilia* were wretched,' thought Aubrey's friend and early biographer, the critic Haldane MacFall. It is not a rigorously critical assessment, but one may understand what MacFall meant.

It may be true that Beardsley's early work suffers from a lack of discipline, a poor technique and, perhaps, a certain derivative character. Yet the boy had had no formal training, and while his family did not actively discourage his drawing, Ellen's pretensions had been for music first, then literature, with 'art' coming, if at all, a poor third on her list of priorities. Beardsley's *juvenilia* suffer most from the absence of proper subject or direction. His work is by no means

A pen and ink caricature of Paganini, 1888, by Aubrey Beardsley, influenced by a Georgian lithograph of the composer.

without interest or charm. There is often real humour in his sketches – for example in an early series of illustrations to the *Aeneid* – and real, although always idiosyncratic, beauty – as in, for example, some of the 'Theatre of Varieties' programmes, or his sketch of the composer Paganini.

Aubrey himself was always the first to recognize his own shortcomings. In May 1890, he had collected all the drawings he had made to date, and pasted them carefully into a scrap-book. He was saying goodbye to his childhood: from now on, he would take art seriously. It is, however, very difficult to identify the form that this new approach took. Almost no single drawing he made over the next two years has survived. Indeed, in later years he would hunt down any which had escaped destruction, exchanging, to the frustration of the many friends and connoisseurs who collected his work, more recent, more accomplished performances for what he seemed to consider the detritus of his youth.

Throughout his early years in London, Beardsley maintained his close friendship with G. F. Scotson-Clark, who had left school and was employed as a clerk by a local wine merchant. The railway to Brighton was quick and cheap and, as often as they were able, the one visited the other. In the spring of 1891, Aubrey took a fortnight's holiday in Brighton, and spent a 'glorious' time with Clark, both of them sitting up late into the night drawing, talking and building 'castles in the air'. One evening Clark showed Aubrey how to mix paints, and Beardsley became intensely absorbed in the revelation. When Clark woke the next morning, he found his friend still awake, having worked all night on a painting of a girl with 'a green face and blue hair against a purple sun'. Perhaps it was after this experience that the two boys dreamed of going to art school, and of opening a Bond Street shop selling

nothing but 'little original drawings in black and white'.

Scotson-Clark's employer was an avid collector of the work of the painter-poet Dante Gabriel Rossetti, and the boy lost no time in initiating his old friend into the joys of 'the new outlook', as they termed it, of the Pre-Raphaelite Brotherhood. This initiation was the single most important influence on the development of Beardsley's art, and inadvertently provided his breakthrough into the great world.

It seems now scarcely credible that, so passionate about the arts, the boys should have remained so long in ignorance of the Pre-Raphaelites and their extraordinary vision. The best, at least the most famous, works of their school – by, for example, Rossetti and Ford Madox Brown – were as much as thirty years old. Yet, in some ways, it proved fortunate that Beardsley had had this revelation so late, for 'the new outlook' provided him with a new and irresistible artistic inspiration.

The Pre-Raphaelites' style, especially in their drawings and prints, was perhaps the most distinctive that England has ever produced. Looking back to the hyper-realism of Mantegna, Botticelli and other pre-Renaissance Italian artists, the Pre-Raphaelite 'Brothers' William Morris, Rossetti, Ford Madox Brown and the critic John Ruskin reinvented a unifying conception of Beauty and Morality which was to express, despite vigorous early critical opposition, the quintessence of the Victorian age.

Beardsley's eye seized upon their taste for the Beautiful, but it ignored – indeed barely even noticed – their passion for the Moral. In 1891 he embarked on a new artistic tack. He gave up the idea of being a writer, for, having 'in vain... tried to crush it out' of himself, 'that drawing facility would come uppermost'. Within a few months, taking his inspiration from a combination of the modern and the ancient Pre-Raphaelites, he evolved for himself 'an entirely new style', mannered and precise, decorative yet full of subject and incident.

One July Sunday in the long hot summer of 1891, Aubrey and Mabel took a tour of the house of the industrialist Frederick Leyland, whose 'Peacock Room', designed by James Whistler, was still causing excitement and controversy with its bold mixture of baroque and Japanese decorations, while his collection of pictures was widely admired as one of the finest in London. Beardsley, in slack-jawed awe, was able to admire the work not only of Whistler, but of Sir Edward Burne-Jones and John Millais, and view Leyland's fine Old Masters, including works by Fra Lippo Lippi, Botticelli and da Vinci. They were 'GLORIOUS', he told Scotson-Clark, in a long and profusely illustrated letter, listing every picture in the collection.

Aubrey was so impressed by the work of Burne-Jones in particular, that he decided, the next week, to go to visit the studio of 'the greatest living artist in

Withered Spring, *1892.*
The prominent inscription
in the middle of the drawing
reads 'Ars Longa'. The viewer
must insert for himself the
implied 'Vita Brevis'.

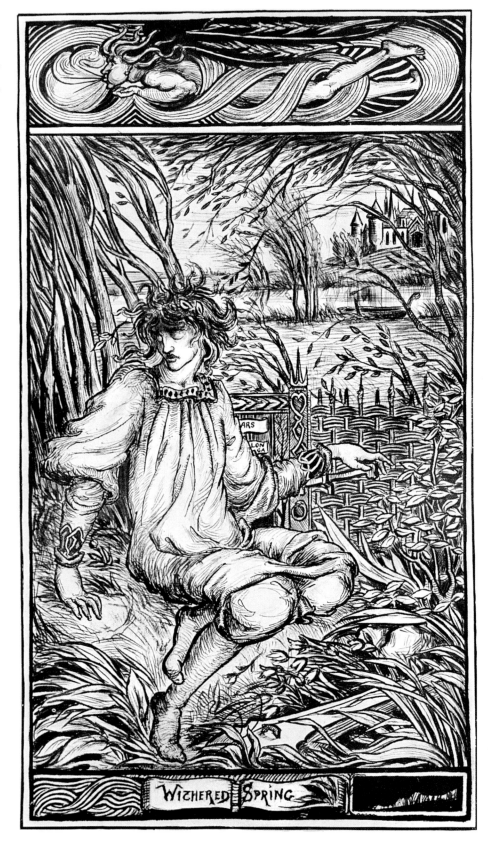

Europe'. On Sunday 21 July, his portfolio under his arm and Mabel in tow, Beardsley rang the bell of The Grange, Burne-Jones's large Kensington house, and presented his visiting card. Instead of being shown round as they had hoped, the Beardsleys were informed by the servant that the studio was no longer open to the public: that arrangement had long been discontinued. Disconsolately, the two began to retrace their journey back to town. As they walked, they heard

> …a quick step behind… and a voice which said 'Pray come back. I couldn't think of letting you go away without seeing the pictures, after a journey on a hot day like this.' The voice was that of Burne-Jones, who escorted us back to his house, and took us into the studio, showing and explaining everything. His kindness was wonderful, as we were perfect strangers, he not knowing even our names.

After their tour Beardsley was easily cajoled into showing his own work to the Master. The reaction he received was more than anything he could have expected, for instead of an embarrassed perusal followed by modest praise and a curt dismissal, Burne-Jones was – at least according to Aubrey's account – bowled over by the contents of the portfolio. After looking through all the drawings at great length, he made a surprising pronouncement: 'I seldom or never advise anyone to take up art as a profession; but in your case I *can do nothing else.*'

Burne-Jones took the Beardsleys into the garden where a gathering of his friends were having tea. 'All congratulated me on my success, since "Mr Burne-Jones is a very severe critic."' 'The greatest living artist in Europe' gave Beardsley a last piece of advice to leaven his fulsome praise. Correctly perceiving that Beardsley's skills did not extend beyond pen and pencil, but not understanding that the drawings were not *sketches* but finished drawings in themselves, he recommended that the boy go to art school, to learn some discipline and technique. He said, however, that only 'two hours' daily study would be sufficient… I myself did not begin to study till I was twenty-three.'

Aubrey Beardsley was now eighteen years old, in his own estimation 'with a vile constitution, a sallow face and sunken eyes, long red hair, a shuffling gate, and a stoop'. In two years he would be famous. By the time *he* was twenty-three he would be the most celebrated – and the most notorious – artist in England.

Sir Edward Burne-Jones in his garden in Kensington. (Hulton Getty)

Self-Portrait, 1892, of Aubrey aged 18. (Mary Evans Picture Library)

2

'STRANGE AND FASCINATING ORIGINALITY'

Given the tragically short span of his life, it is doubtful that Aubrey Beardsley would ever have been able to achieve his phenomenal success without the encouragement of Sir Edward Burne-Jones. Such fulsome praise from so legendary a figure was exactly the impetus Beardsley needed to set about 'art' in earnest. Only a week before, he and Scotson-Clark had applied to, and been rejected by, the Herkomer School of Art (the 'Gloryhole', as they called it). Aubrey could not in any case have afforded to leave the Guardian office for full-time study outside London, but now that disappointment seemed slight: with Burne-Jones's 'two hours' study' ringing in his ears, Beardsley looked for a two-hour education.

The following week, Burne-Jones wrote suggesting two schools: the South Kensington, which offered an intensive studio-based training, and the Westminster, which was run by Frederick Brown, an artist fresh from success and training in Paris. To help himself decide, Beardsley went to see the painter G. F. Watts, 'a disagreeable old man' who unhelpfully advised him to go to no school at all. In the end the choice was not hard to make: since the South Kensington School had a rigorous entry procedure, Aubrey chose Brown who, he said, 'seems to have great hopes of me'. As well he might have had. At the Westminster School, under Brown's guidance, Beardsley began slowly to refine his powers. A draughtsman of both talent and originality peeps out for the first time from behind the curtain of caricature and imitation.

But mere talent was no security for an illustrator. In that field more than almost any other it was, as it still is, necessary to have patrons, men who would

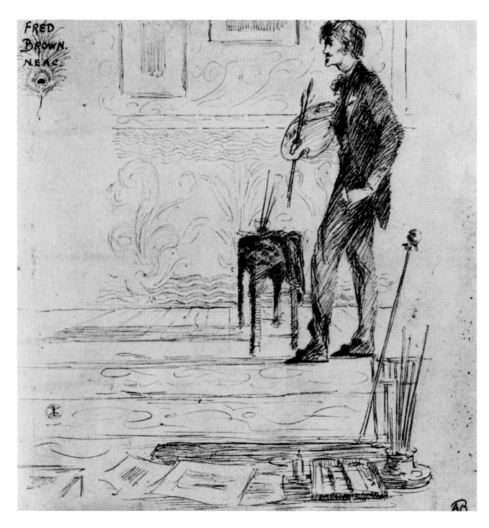

Pencil and ink sketch of Professor Fred Brown, 1892. Beardsley's monogram at the bottom right, and the style of the drawing itself, irresistably suggest the work of Whistler.

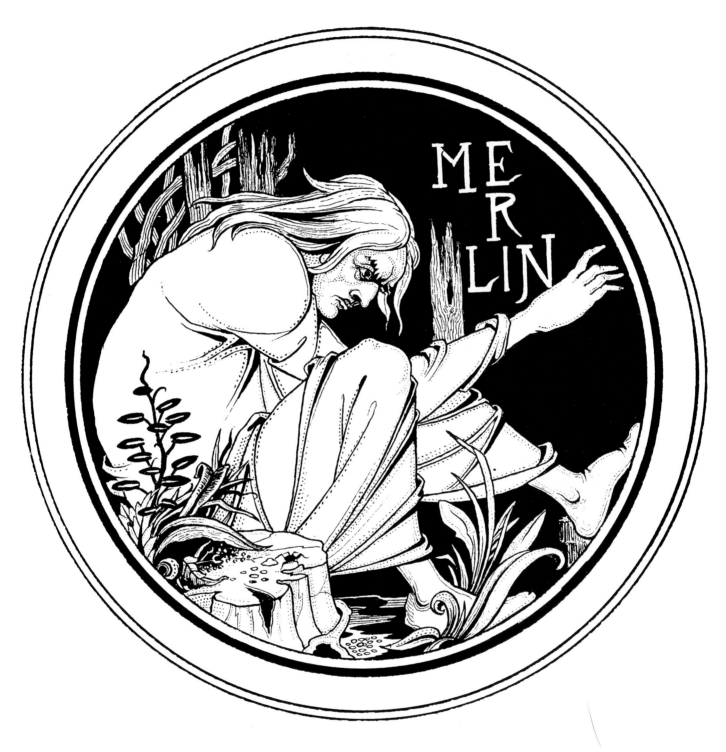

Merlin, *1892, from the* Morte Darthur.
The influence of Mantegna on Beardsley's
early style is clearly discernible here.

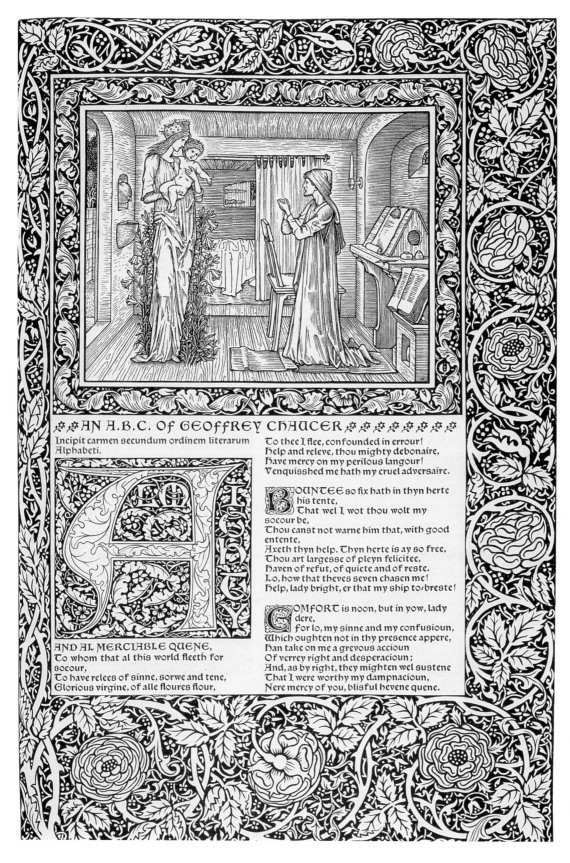

Page from the Kelmscott Chaucer, 1896, by Williams Morris and Sir Edward Burne-Jones. Beardsley's Morte Darthur *would place a higher premium on legibility.*

Robbie Ross in later years: 'Several people have claimed to discover Aubrey Beardsley, but I think it truer to say that he revealed himself.'

promote the work, arrange publicity and secure commissions. Beardsley was always fortunate in this respect. His personal charm, quite apart from his unique gifts, was sufficient to make influential people 'take him up'. The first, and the most dedicated of these was to be Aymer Vallance, a middle-aged scholar and antiquary who had been told about this young and prodigiously gifted draughtsman by the Revd C. G. Thornton, a Brighton friend of the Beardsleys.

Vallance's passion for Victorian gothick could hardly have better coincided with Beardsley's ersatz Pre-Raphaelitisms, but for months he put off visiting a young man whom he had heard praised in such fantastic, even unbelievable terms. When, during the Christmas holidays of 1891, Vallance did eventually visit Charlwood Street, he realized that Thornton had made no overstatement. Overwhelmed by the quality of Aubrey's talent, over the coming months Vallance talked about Beardsley to legions of editors, writers and critics, in the hope that one of them might discern what he himself had seen in Aubrey's portfolio. If, for the most part, they did not, they cannot greatly be blamed. The day had not yet come for Beardsley's style, and the young artist laboured under one almost insurmountable handicap. It was an age which venerated middle-age – a man was still, officially, 'young' until he reached at the earliest his mid-thirties – and Aubrey Beardsley was not yet out of his teens.

Vallance was a close associate of many of the older generation of Pre-Raphaelites, in particular of William Morris, whose Kelmscott Press, one of the most audacious publishing initiatives since the invention of movable type, was beginning to produce its first books. Weary of the uniformity and poor quality of contemporary book-work, and inspired as always by his pedantic ideas of the social and moral duty of art, Morris had decided at the dawn of the Nineties to found a press which would project a return to the golden days of printing. Vallance was sure that Beardsley, with his Burne-Jones manner, would be just the sort of illustrator Morris needed for Kelmscott's new edition of *Sidonia the Sorceress*, in a translation by Lady Wilde. Understandably, Aubrey needed very little persuasion to make a sample drawing for Morris.

Thus, one afternoon during the summer of 1892, Vallance and his protégé made a confidently hopeful journey to Kelmscott's Hammersmith workshops. The visit was not a success. Unlike Burne-Jones, Morris could summon no enthusiasm for what he saw in Beardsley's portfolio. All he could see was the work of an untried, immature artist, whose drawings, although sometimes following the principles of the PRB, were too modern and idiosyncratically *different* for Kelmscott.

*Portrait of J. M. Dent by Dora Noyes. Dent became one of
the most influential and intelligent publishers of his day.*

Hoping, in his gruff, patronizing way, to cushion the
blow, the best advice he could give Beardsley was to
cultivate his latent talent for drapery. Aubrey was
mortally insulted: in a fit of frustration and anger, he
destroyed his drawing, and vowed never to return.

Some, however, did take to the artist. Robbie
Ross, the Canadian journalist who by his tact and good
humour was to prove one of the linchpins of the cir-
cle of writers and artists who congregated around
Oscar Wilde, became an immediate admirer when
they met through Vallance in February 1892.

Vallance had evidently primed Ross thoroughly,
yet, 'though prepared for an extraordinary personality',
he remembered, 'I never expected the youthful appari-
tion which glided into the room.' Even once the strings
of the inevitable portfolio were opened, Ross found his
attention wandering from the strange new worlds of

Aubrey's imagination, 'so over-shadowed were they by
the strange and fascinating originality of their author'.
Ross's wide circle of friends and acquaintances was to
prove as invaluable to Beardsley as his friendship.

Others, too, followed his career with interest.
A.W. King, who had transferred from Brighton to the
Blackburn Technical College, continued to promote his
former pupil within his own less exalted circle, circu-
lating the boy's drawings among artistic friends, and
arranging for Beardsley's first appearance in print as a
draughtsman. The November 1891 edition of *The Bee*,
a magazine run by King for the college, reproduced, in
sanguine ink, Aubrey's *Hamlet Patrem Manis Sequitur*.
The drawing, executed in his most faithful Burne-
Jones manner, is Beardsley's first masterpiece. It is also
a poignant reminder of his own mortality: 'Hamlet,
following the ghost of his Father through a dark wood'
seems to symbolize Beardsley's life. Tuberculosis, in
the final reckoning, was Aubrey's sole patrimony.

So, his life increasingly split between 'business' and
art, Beardsley gradually became known about, without
ever making any real headway in securing work. During
intermittent illnesses in the early months of 1893, his
convalescences, instead of being times of idleness and
boredom, enabled him, as he told Scotson-Clark, to
'forge ahead with the drawing with renewed vigour',
and to continue to develop his own style.

He was also looking at Japanese pictures, in par-
ticular the woodcuts of artists like Utamaro and
Hokusai which were beginning to make their way in
greater numbers to England. Aubrey, inspired by the
economy of line which he found in them, 'struck out a
new style... founded on Japanese art, but quite origi-
nal in the main.' 'Fantastic in conception, but perfectly
severe in execution', combining elements of Whistler,

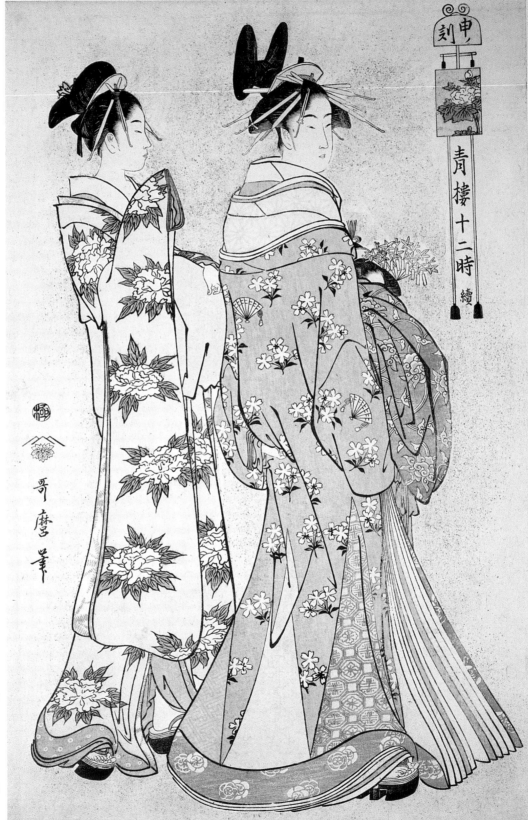

The Hour of the Monkey, *by Kitagawa Utamaro. Japanese art had a profound impact on many artists of the period. (The Bridgeman Art Library / British Library, London)*

Burne-Jones and the Orient, the 'new style' was not entirely original, but it was certainly distinctive. During the spring of 1892 he produced more than twenty major drawings in this manner and variations upon it.

When, as he did with all his work, he showed his new drawings to the Master, Burne-Jones did not approve. The disciple, Sir Edward thought, instead of acquiring discipline, was leaning towards frivolity and decadence. Beardsley was unabashed by Burne-Jones's criticism, and drew a little sketch of himself being booted down the stairs of the National Gallery by Mantegna.

In the summer of 1892, his portfolio bulging with his new work, Beardsley made his first visit to Paris, which figured, for the English, as the Mecca of the Arts. He went alone, and probably spent much of his time studying at the Louvre, but Burne-Jones had given him letters of introduction to various figures, including, among others,

Chapter heading from the Morte Darthur.

Puvis de Chavannes, president of the Salon. De Chavannes was amused, even impressed, by the young Englishman, and when he introduced Beardsley to 'one of his brother painters as "*un jeune anglais qui a fait des choses étonnantes*"', Beardsley must have known that he was not long for his clerical career.

On his return from France, Beardsley vowed that from now on his life would be dedicated to Art. He had made the pilgrimage to Paris, and enjoyed a success; he had the support and encouragement of men whom the world admired and respected; and, while no man knows when Death will come, he was beginning to realize that it might knock at any time. The same is of course true of opportunity.

During lunch hours and after work at the Guardian office, Beardsley's consuming passion for literature regularly led him, as it did so many other young men like him, to Jones and Evans, a Cheapside bookshop often referred to as the

'university of the City clerk'. Frederick Evans's shop was a haven of tranquillity in the bustling City, where customers were not only allowed but actively encouraged to browse through the wide-ranging stock.

Evans, with his wide interests and beneficent character, ran his shop like a liberal public library. Over time, his attention became engaged by the painfully thin young man who seemed sometimes to be a daily presence among his stacks. Gradually, between the gregarious bookseller and the 'shy, nervous and self-conscious' clerk there grew up first an acquaintance, and then a friendship. When Evans discovered that the boy drew, he was only too happy to peruse that 'well-travelled portfolio' for which Aubrey was only too keen to have an audience. Interested in what he saw, they struck a bargain: Evans would accept Beardsley's drawings in exchange for books, an arrangement which suited both admirably.

One lunchtime during the summer of 1891 Beardsley entered the shop to find his bookseller in confabulation with a fat and fearsomely bearded man. Always diffident, and expecting nothing more than a nod of recognition, he was surprised to be greeted with a shout of 'There's your man!' The *barbu* turned out to be J. M. Dent, a former printer who was beginning tentatively to turn his hand to publishing books on his own account. He and Evans had been discussing Sir Thomas Malory's *Morte Darthur*, a text undergoing something of a vogue at the time.

LEFT: The Achieving of the Sangreal, *1892. This drawing by Beardsley marks the high point of Sir Edward Burne-Jones's influence.*

ABOVE: *Plate from the* Morte Darthur *in the William Morris manner.*

Evans had suggested that Dent should not merely issue another standard edition but bring out an illustrated version of the book. Citing the Kelmscott Press, he proposed that a new publisher could do worse than to follow, using modern – cheap – printing techniques, the course taken by Morris. Where, though, could one find an illustrator to work like Burne-Jones 'without the Burne-Jones fee'?

The founder, a few years later, of the Everyman Library of classic texts in cheap editions, Dent would have found Evans's proposal quite foreign to his own tastes, but when the bookseller brought out some 'Beardsleys' he had to hand, the publisher's imagination was immediately gripped. It was at this moment that Aubrey had entered the shop. Beardsley was asked to produce a sample drawing and, when he returned a few days later with *The Achieving of the Sangreal*, one of the most assured of his drawings in the Burne-Jones manner, Dent confirmed the commission. Evans's 'hunch' had proved to be correct.

Here was Aubrey's breakthrough. Comprising 'twenty full-page designs, about a hundred small drawings in the text, nearly 350 initial letters and the cover', the *Morte Darthur* commission would constitute a phenomenal amount of work, for the comparatively modest fee of two hundred pounds. As Beardsley was the first to realize, Dent had 'seen his chance'. He had found his cut-price Burne-Jones – 'the lucky dog'.

Beardsley did not immediately start work. It would take time before the page designs and layouts would be approved and a reader's text prepared. J. M. Dent, in a pattern which was to recur over and again in Beardsley's professional life, was determined to get the most out of his new talent and soon discovered several projects on which Beardsley could try his hand. The first to come off the press was an edition of Fanny Burney's *Evelina*, for which Beardsley made a frontispiece, as well as a design for the binding in an uncharacteristically rococo style. Other publishers – Cassell's, Lawrence and Bullen, John Lane – started chasing him with offers, too.

The mountains of work Dent put Aubrey's way provided exactly the impetus that the artist needed to be able to leave his job at the Guardian office, an escape that he effected in October 1892 'at his sister's strong urging and solicitation'. 'If ever there was a case of a square boy in a round hole, it was mine,' he told Mr King. Yet despite his success, and the strain that office life had put on his health, Beardsley's mother and father were not convinced about their boy's ability to sustain an income. Aubrey won through – by ignoring

BELOW: *Grotesque from* Bon Mots, *1893.*

Birth from the Calf of the Leg, *from* Lucian's True
History, c. 1894. *'They opened their great stupid eyes pretty
wide; frightened of anything so new and so daringly original.'*
(The Bridgeman Art Library / The Stapleton Collection)

them. 'There were ructions at first, but now I have
achieved something like success and [am] getting
talked about they are beginning to swear they take the
greatest interest in my work. This applies principally
to my revered father.'

He left a poignant memorial of his clerical appren-
ticeship in the drawing *Le Débris* [sic] *d'un Poète* – whose
misspelt French does little to convince us that he was
as fluent in the language as he affected to be.

After *Evelina*, in October 1892 Dent put
Beardsley on to his *Bon Mots* series of the sayings of

English Wits. It was not a 'serious' commission, fortu-
nately, and, equally fortunately, neither he nor Dent
ever took the hundred or so thumbnail sketches he
made very seriously. They are engaging things, those
'strange hermaphroditic creatures walking about in
Pierrot costumes, quite a new world of my own crea-
tion', done in the Japanese manner he had invented in
the summer, and the books themselves, published the
next year, are charming little objects, redolent of their
period.

With a poor visual sense except when it came to
arrangements of type, Dent had given Beardsley a free
rein on *Bon Mots*, and in these illustrations the seeds of
many of the recurring themes of Beardsley's future
development – from his delicate, precise traceries, to
compositions that use only the bare minimum of line,
to the aborted foetuses on which he was to become so
fixated – can be discerned. They also provide the first
indication of an impishly macabre vein in his imagina-
tion, one which would become more and more appar-
ent as time went on.

That nascent taste for the macabre would soon
cause trouble. Following hot on the heels of *Morte
Darthur*, one of Aubrey's first commis-
sions had been to illustrate a new edi-
tion of the *True History of Lucian*, the
book on which More's *Utopia* had
been based. As he always did with
new projects, Beardsley struck out
immediately and confidently. 'The
drawings,' he boasted to Clark, 'are
certainly the most extraordinary
things that have ever appeared in a
book… They are also the most
indecent.' They were certain-
ly that. He was taken off the

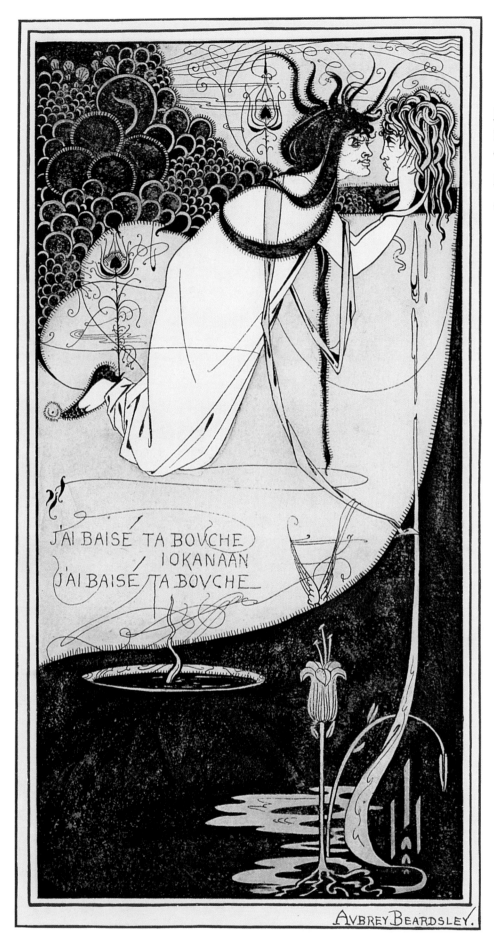

J'ai Baisé ta Bouche, Iokanaan, *published in* The Studio. *Beardsley later cast this green wash over the drawing.*

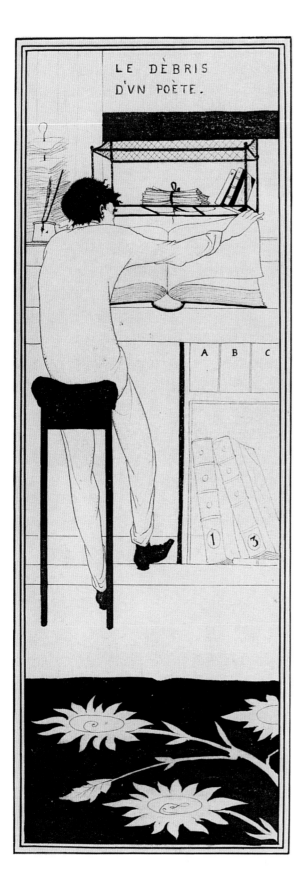

job having made only five pictures, of which only two were used in the volume as published. His designs were on the one hand too inconsistent in style, and on the other too frank in detail. The publishers, he boasted, had 'opened their great stupid eyes pretty wide; frightened of anything so new and so daringly original'. They decided to farm the rest of the book out to less adventurous hands.

Vallance's commitment continued to arouse interest in Beardsley. Late in 1892, the boy's immediate future secure, Aubrey was taken by Vallance to the literary salon of Wilfred and Alice Meynell, to meet C. Lewis Hind, who was about to establish a new 'artistic' magazine called *The Studio*. He needed a big sensation with which to launch it, and initially doubted that the diffident, etiolated youth, who with anxious eyes watched him inspect the portfolio, could possibly offer what he needed. But his indifference melted away as he looked through Aubrey's work. 'Either this is genius,' he exclaimed, 'or I am mad.' Later, Hind would remember what the portfolio had contained: 'In each drawing there was mastery. When I [say] that... he showed me... the *Birthday of Madame Cigale*, *Les Revenants de Musique* and *Act II of Siegfried*, you will realize what an astonishing degree of proficiency his art had reached.'

Hind came away from their meeting 'confident that we had found the unique thing for the new magazine,' and his enthusiasm seemed to know no limits. Having offered Aubrey a place on the staff of *The Studio*, he commissioned a 'Beardsley' cover for the magazine, and asked Joseph Pennell – a well-known

Le Dèbris d'un Poète, *1892, Beardsley's farewell to his clerical career.*

vious year. At the beginning of 1893, he took several of Aubrey's *Morte* drawings down to Hammersmith in the hope that Morris would see how mistaken he had been. He went alone, for Beardsley, whose treatment at Morris's hands still rankled, himself refused to go.

The effect of the *Morte* drawings was powerful and instantaneous, but not at all what Vallance had hoped for. On the contrary, Morris exploded in anger, declaring Beardsley's work to be 'an act of usurpation' of ground which he believed Kelmscott had marked out for its own. 'A man should do his own work,' he thundered. Beardsley was neither surprised nor very upset when Vallance reported all this, and the inconsistency of Morris's position was not lost on him: 'The truth is, his work is a mere *imitation* of the old stuff; mine is fresh and original.' Despite his arrogance, Beardsley was right. Kelmscott books, for all their precious, hard-won beauty, were anachronisms; their price was exorbitant, and Morris's blunt refusal to take advantage of new techniques and processes has relegated them to the position of mere 'interesting footnotes' in the history of printing, while Beardsley's *Morte* still looks as 'fresh and original' today as it did then.

'William Morris has sworn a terrible oath against me for daring to bring out a book in his manner,' Beardsley told Scotson-Clark in a smugly self-confident letter at the beginning of 1893. 'My dear boy, I have fortune at my foot...' Proud, even boastful in tone, it was to be Beardsley's last message to Clark, who had emigrated to America. The ties that bound Aubrey to his Brighton youth were cut.

artist and critic whose own book on *Pen Drawing and Pen Draughtsmen* had made him the acknowledged authority in the field – to write an appreciation of this 'unique thing'. With several of Beardsley's most recent drawings, including four from the shortly-to-be-published *Morte Darthur*, and the weirdly gruesome *J'ai Baisé ta Bouche, Iokanaan*, an illustration to Oscar Wilde's play *Salome*, Aubrey Beardsley was the 'star' of *The Studio*'s first number.

In the light of Beardsley's new-found vogue, Aymer Vallance assumed that William Morris would now be prepared to take a fresh look at the work of an artist whom he had so dismissively rejected the pre-

HOW. MORGAN. LE
FAY. GAVE. A. SHIELD.
TO. SIR. TRISTRAM.

It was bookseller Frederick H. Evans who suggested to his friend publisher J. M Dent that Beardsley might be able to create 'Burne-Jones-ish' illustrations for his planned illustrated Morte Darthur. *Dent demanded a sample. Beardsley sent* The Achieving of Sangreal *(see page 134) and the commission was confirmed.*

Full-page border of decorated initial for the Morte Darthur. The black-and-white theme is continued in the design's subtle iconography with angels set against devils, lilies against poppies. The edition was published in parts during 1893 and 1894.

3

'I HAVE FORTUNE
AT MY FOOT'

It is uncertain when Oscar Wilde and Aubrey Beardsley met for the first time, but the introduction was certainly effected, at the very latest by the end of February 1893, through the agency of Robbie Ross. Oscar's star was firmly in the ascendant. His first play had been a phenomenal popular hit; his second was in rehearsal; his novel *The Picture of Dorian Gray* had scandalized and delighted those who wished to be scandalized or delighted; and he was fast becoming known, with his lightning wit, gregarious generosity and prodigious charm, as the figure-head of a new and exciting movement in literature.

In late February 1893, John Lane published *Salome*, Wilde's fantastical Byzantine dramatic treatment of the biblical story of John the Baptist, in the French in which it was written. The play was already notorious. In June the previous year, the Lord Chancellor had refused to allow Sarah Bernhardt to produce it on the London stage because of an old statute which banned the dramatic portrayal of biblical figures, and the newspapers had made excellent copy out of Wilde's consequent threats to emigrate to France in protest at English philistinism.

Beardsley was impressed by the play's atmosphere of literary luxuriance, and fascinated by its fantastic word-pictures: the play seemed to be the literary counterpoint to his own mind's weird vision. Fired with enthusiasm, he made a drawing of the 'climax' of the drama, the moment at which Salome receives the severed head of John the Baptist, and persuaded *The Studio* to include it in its profile of him. It was a none-too-veiled 'pitch' at a commission to make an illustrated edition of the book.

Wilde had certainly seen Aubrey's drawing before *The Studio* came out in April 1893. In the copy of the book he had presented to Beardsley in March, Oscar's inscription read: 'For the only artist who, besides myself, knows what the dance of the seven veils is, and can see that invisible dance.' By May they seemed firm friends, with Beardsley boasting that he was 'off to Paris with Oscar Wilde', but in the event Wilde stayed at home and Aubrey, having bespoken a new wardrobe which he thought 'Paris and Art demanded of him' went instead with Joseph and Elizabeth Pennell.

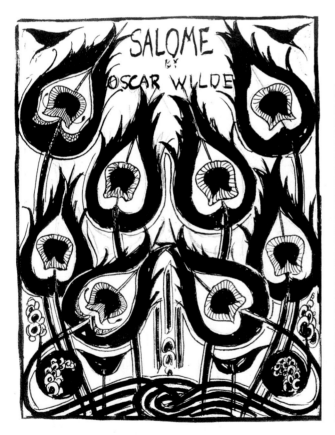

Original sketch for the front cover of Salome *— one of the few unfinished Beardsley drawings to survive destruction. (The Bridgeman Art Library / The Stapleton Collection)*

Oscar Wilde in 1891. Once asked why he liked to annoy the public so much, he replied 'the public likes to be annoyed'. (Hulton Getty)

L'Apparition *by Gustave Moreau. The legend of Salome was a favourite of* fin de siècle *artists. (The Bridgeman Art Library / Musée Gustave Moreau, Paris)*

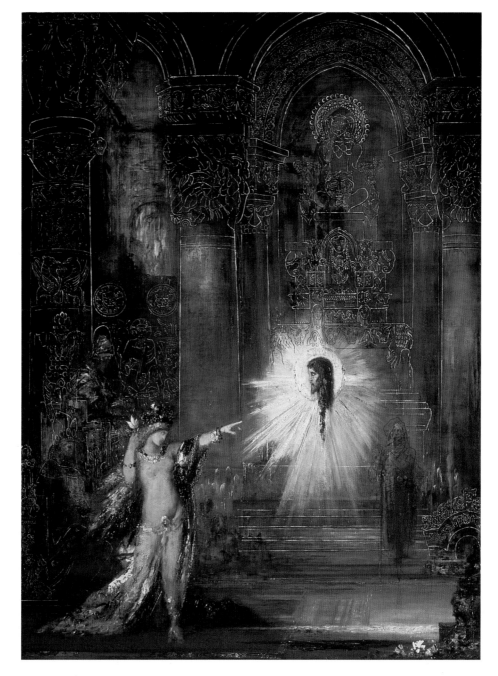

Dressed entirely in shades of grey, Beardsley drew gasps of admiration as one of the 'most striking figures' at the New Salon, and to his eminent satisfaction attracted the 'stares of the crowd' wherever he went. His appearance caught the jaundiced eye of the notorious quarreller 'Jemmy' Whistler, who, believing that only *he* was allowed to make a show of himself, determined to insult Aubrey at every opportunity. Alluding to Beardsley's just-published *Bon Mots* drawings and their 'hairy-line' style, Whistler asked Pennell the identity of 'that young thing...' with 'hairs on his

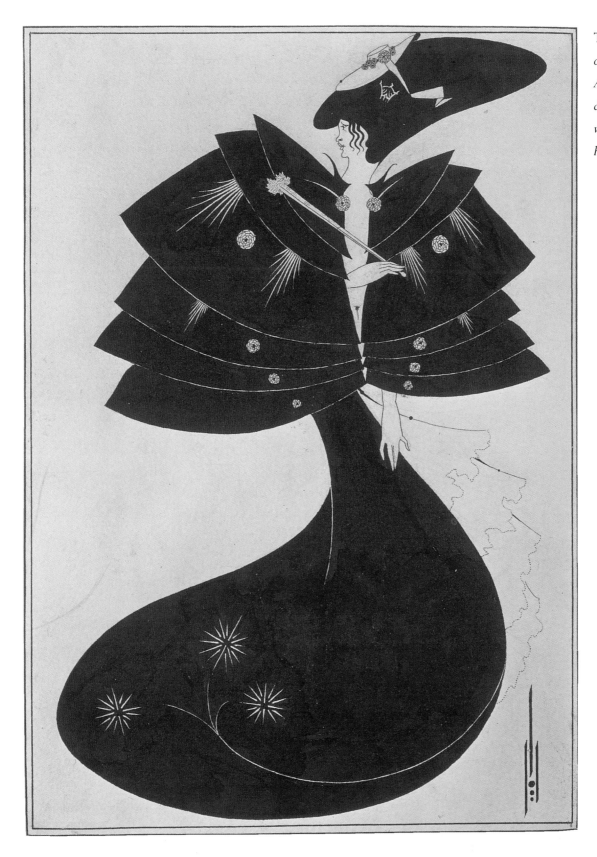

The Black Cape,
one of the few of
Aubrey's Salome
drawings over
which John Lane
had no fears.

hands, hair in his ears, all over?' Informed that Aubrey was a 'coming man', Whistler made a point of cutting the younger artist at every opportunity.

New friends were made, nevertheless. Among them was William Rothenstein, a young Englishman rapidly establishing a reputation as an artist of great promise. Rothenstein, a quiet, gentle man, a fine portraitist and lithographer, was, like Beardsley, barely twenty-one. Aubrey was intrigued by Rothenstein's modesty in success; Rothenstein, in his turn, was delighted by 'this strange young man, with his too-smart clothes with their hard padded shoulders… his spreading chestnut hair, his staccato voice and his jumpy, nervous manners. He appeared a portent of change.'

John Lane, Wilde's publisher, was among the first of a new breed of bookman which appeared in the 1890s. Like Dent, he was a relative newcomer to the trade, having been employed until recently as a clerk in the Railway Clearing House, becoming a publisher after a brief stint as a bookseller. With a legendary flair for publicity, and nose for the 'new thing', he managed, in a very short time, to build up a highly creditable list for his Bodley Head imprint.

Lane had recruited Oscar Wilde in 1892, when he bought the unbound sheets of two hundred unsold copies of Oscar's first (1881) book of *Poems*, substituting his own imprint for the original title-page. Thereafter almost all the major figures of 'decadent' literature, from Richard La Gallienne and Ernest Dowson to Baron Corvo and Lionel Johnson, came at some point to publish with him. In 1893 he was, simultaneously, bringing out Oscar's plays *Lady Windermere's Fan* and *A Woman of No Importance*, as well as his poem *The Sphinx*, in a ravishing edition designed by Charles Ricketts and Charles Shannon. Having made unsuccessful overtures to Beardsley in 1892, when asked to issue an Englished *Salome* illustrated by Aubrey Beardsley, Lane had no hesitation in agreeing. To publish Wilde was prestigious, and lucrative, enough, but to acquire the famous new illustrator in the same package seemed too good to be true.

The contract was signed in June 1893. Lane offered fifty

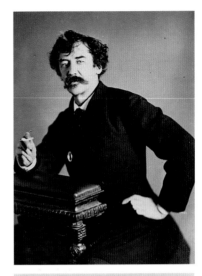

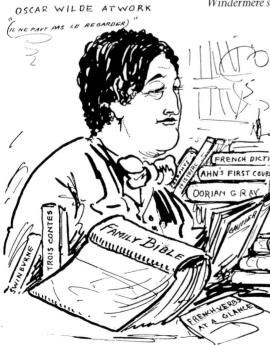

OSCAR WILDE AT WORK
"(IL NE FAUT PAS LE REGARDER)"

TOP *James Abbot McNeill Whistler, the 'miniature Mephistopheles, mocking the majority.' (Hulton Getty)*

ABOVE *John Lane. Lane would publish 'anything — even poetry — with what he hoped was the scent of dying lilies about it.'*

LEFT Oscar Wilde at Work. *An anonymous caricature in Beardsley's style. (Hulton Getty)*

pounds for ten drawings, a frontispiece, and a cover design. In a significant gesture, Beardsley insisted on the slightly higher sum of fifty guineas: tradesmen were paid in pounds, gentlemen in guineas. Even more importantly, one of Whistler's most famous public quarrels had been over his payment in *pounds* for his work on the 'Peacock Room', a fact of which Beardsley could hardly have been unaware.

Blithely ignoring the increasingly severe deadlines on the *Morte Darthur*, he started work immediately on his *Salome* drawings. It quickly became apparent that Aubrey was only too alive to the overblown, sometimes even absurd grandiosity of Wilde-the-artist. Will Rothenstein, returned from Paris and himself working on a book of portraits for John Lane, often used Beardsley's studio over the summer, and recalled that a photograph of Wilde, which Beardsley frequently consulted while working, was placed prominently over the mantelpiece. The reason soon became clear: several of the drawings featured prominent caricatures of Oscar.

When Wilde saw Beardsley's work in progress, he suspected that the offence of *lèse-majesté* was being

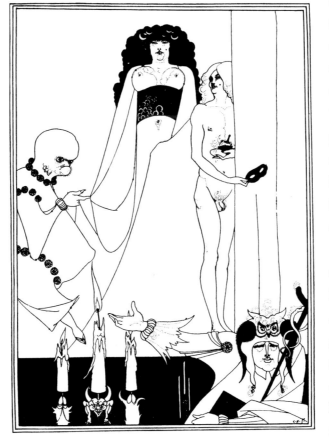

Enter Herodias, *1893, from* Salome. *Oscar Wilde, holding a copy of the play, is caricatured as Salome's fool*

perpetrated against him. The drawings seemed to mock both him and his play. Too often they seemed to be less illustrations of his text than detachedly ironical, amused parodies of it, and despite his often-stated belief that illustrations must not cleave too closely to their text – should 'stir the imagination', not 'set definite bounds to it' – Oscar thought Beardsley's drawings little more than 'the naughty scribbles a precocious schoolboy makes on the margins of his copybooks'. He could find few who would confirm his opinion.

Even with his tongue so firmly in his cheek, Beardsley was inspired by *Salome* to some of the greatest moments of his art. Masterpiece after *chef-d'œuvre* flowed from his pen, from *The Peacock Skirt*, generally thought the triumph of his early decorative manner, to the bold hyper-simplification of *The Black Cape*.

Highly attuned to the latent, unsated sexuality in the play, the pictures are charged with an eroticism which led to disputes with Lane, who felt obliged to veto several as being too indecent for publication. Lane rejected three illustrations outright: the first version of *The Toilet of Salome*, which contained the figure of a masturbating boy among other 'indelicacies';

Salome on a Settle, in which Salome was holding an implement rather too suggestive in purpose for Lane's liking; and *John and Salome*, in which he appears to have seen depravity lurking in every fold of Salome's cloak. Each time a drawing was rejected, Beardsley responded by producing others which strayed even further from the text, and which were, as he said, 'simply beautiful and quite irrelevant'.

Lane began to have nightmares. As each new design crossed his desk, it was minutely examined with a jeweller's magnifying glass, upside-down and all around to ensure that it contained no hidden indecencies. Some drawings were severely bowdlerized. The naked herm in Beardsley's original title page was emasculated, for example, when even Aubrey agreed that booksellers would be hard-pressed to display it in their windows. Yet, despite the closest scrutiny, Lane's anxious eye often missed Beardsley's 'naughty little scribbles'. While insisting that the page's genitals in *Enter Herodias* should be cov-

The Burial of Salome, *1893. Beardsley's signature was inspired by the candlesticks in whose light he always drew.*

ered, which Aubrey effected by use of an over-large, tied-on fig-leaf, Lane failed, to Beardsley's secret glee, to spot the enormous tumescence lurking beneath the robes of the grotesque figure on the left. He was similarly blind to the row of phallic candlesticks at the bottom of the picture.

But neither Oscar Wilde nor John Lane caused the row which, in the autumn of 1893, threatened to sink the whole project. If Wilde dismissed Beardsley as just a 'naughty schoolboy', he was having a greater difficulty with a real schoolboy, his aristocratic lover Lord Alfred Douglas, known as 'Bosie'. The twenty-one-year-old son of the Marquess of Queensberry, a fine sonneteer but a poor excuse for a human being, had been sacked from Oxford in June for refusing to sit his exams. As a favour, and to palliate Douglas's worried family, Wilde agreed to let Bosie translate his play.

Douglas delivered his manuscript in August, whereupon Wilde discovered that it was not only poor literature, but riddled with most elementary errors of translation. But when Wilde nervously pointed out that, for example, the English of '*On ne doit que regarder dans les miroirs*' meant the exact opposite of Douglas's 'One must not look at mirrors', Bosie erupted with fury, declaring that any mistakes in his work were the fault of the original, and refused to change so much as a line.

Inadvisedly, no doubt, Wilde showed Bosie's translation to Beardsley, who, as we have seen, prided himself on the excellence of his French. Aubrey offered to make a fresh translation – a rash offer, considering what he knew of Bosie's temper, for it escalated the fracas to new heights. 'For one week, the number of telegraph and messenger boys who came to the door was simply scandalous,' he told Ross. Oscar Wilde, beset on all sides by Furies – the petulant and

Portrait of Aubrey by Frederick Hollyer. Max Beerbohm described Beardsley as rather remote, rather detached from ordinary conditions, a kind of independent spectator who enjoyed life, but was never wholly of it. (The Bridgeman Art Library / The Stapleton Collection)

headstrong Bosie, Beardsley stirring up trouble, and Lane, who, while insisting on his prerogative over Beardsley's drawings, refused to arbitrate with Bosie – kept his head and managed to placate the various sides: it was solely due to his tact and diplomacy that *Salome* ever appeared.

On her death late in 1891, Beardsley's Pitt aunt, who had tended Aubrey and Mabel with such distant care in their infancy, left generous bequests of five hundred pounds each to her niece and nephew, with the condition that they should not inherit until their twenty-first birthdays. The proviso was made, at least in part, to ensure that the money was kept out of the hands of Vincent Beardsley.

Five hundred pounds was a terrific amount in those days, when a clerk's salary was a yearly seventy pounds at the most. To a young man with aspirations to fashion, and an all-too-finite life expectancy, such a sum, well deployed, would represent an opportunity for some kind of freedom: yet Aubrey used it wisely. Buoyed up by his success, and by the fact that in a month or so he would reach his majority, in June 1893, just before his twenty-first birthday, Aubrey and Mabel Beardsley bought a house, at 114 Cambridge Street, the same Pimlico road in which they had lived when they first came to London.

Beardsley designed the decorations of the apartments himself, calling in Aymer Vallance for practical guidance. A bold scheme of violent orange distemper was chosen for the walls, combined with black detailing for the woodwork, skirting boards and window frames. On the floor were scattered green rugs, and the chairs were upholstered in blue and white – quite a riot of colour. The furniture was thankfully restrained and well selected, in view of the exuberance of the rest: it included a simple black Regency desk at which Beardsley worked, a wicker armchair and a chaise-longue.

The frantically busy summer of 1893 had taken its toll of Beardsley's health. During September, he had been so severely ill that much of the month had been spent laid up in bed and, for some time after, almost any exertion was enough to prostrate him. But he never allowed his life to be limited. At their new house, Mabel's Thursday 'at-homes', would be languidly adorned by her brother, 'dressed in the severest good taste and fashion'. Haldane MacFall remembered Aubrey, 'pallid of countenance and meagre of body, with his tortoise-coloured hair worn in a smooth fringe over his white forehead', irrepressibly cheerful and hospitable at these gatherings. 'But he paid for it with "a bad night" when the guests departed.' The young Max Beerbohm, who met Beardsley through Will Rothenstein and in time became one of his most valued friends and most vocal defenders, described

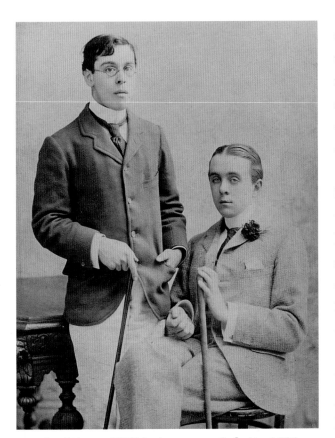

Max Beerbohm and Will Rothenstein in Oxford in 1893.
'To be famous in one's youth is the most gracious gift the
gods can bestow,' said Max. (Courtesy Mark Samuels Lasner)

one of Beardsley's little supper parties: 'Half-formal, half-intimate', Aubrey was 'the life and soul of the party', until his frail constitution took over: then, 'quite suddenly, almost in the middle of a sentence, he fell fast asleep in his chair, his narrow face as white as the gardenia in his coat.'

A difficult relationship with his over-protective and often interfering mother was not helped by Beardsley's own stubborn refusal to take his illness seriously. He would not bow, even a little, under the requirements his physical condition imposed. When in September Ellen virtually forced him to retire to the country to recover from a particularly bad bout of blood-spitting, Aubrey did nothing but pace, moan

and complain about being dragged away from the thick of Life. He was increasingly aware that his own might be only too finite. At the 'health farm' Ellen had selected at Haslemere, she told Robbie Ross, 'his depression was so great, and the life he led me so dreadful that... I gave it up and let him come home.'

Frustration at his own physical frailty was exacerbated by having to spend so much precious energy at the end of 1893 – just as the 'Beardsley Boom' was hitting its first peak – 'hard at work working off arrears for Dent'. The *Morte Darthur*, his first major commission, continued, but where it had once been his passport, it now bored and frustrated him. Not only did it keep him from pursuing other commissions, but the designs had to be executed in a manner which, though barely a year old, he had long outgrown. He was, too, frustrated by the quality of the printing, which he thought did not do justice to the fineness of his line.

At the end of September, with relations between mother and son at their worst, Aubrey began to talk seriously about breaking his contract with Dent. Mrs Beardsley was horrified. She thought it would be 'monstrous' and 'unprincipled' to abandon the book which had made her son's name. Legend has it that he retaliated by teasing her with the following limerick:

There was a young man with a salary
Who had to do drawings for Malory.
 When they asked him for more
 He answered 'Why? Sure,
You've enough as it is for a gallery.'

When he would not listen to her, Ellen turned to his friends, begging them to intervene. Her greatest regret, she told Ross, was that Aubrey was not 'small

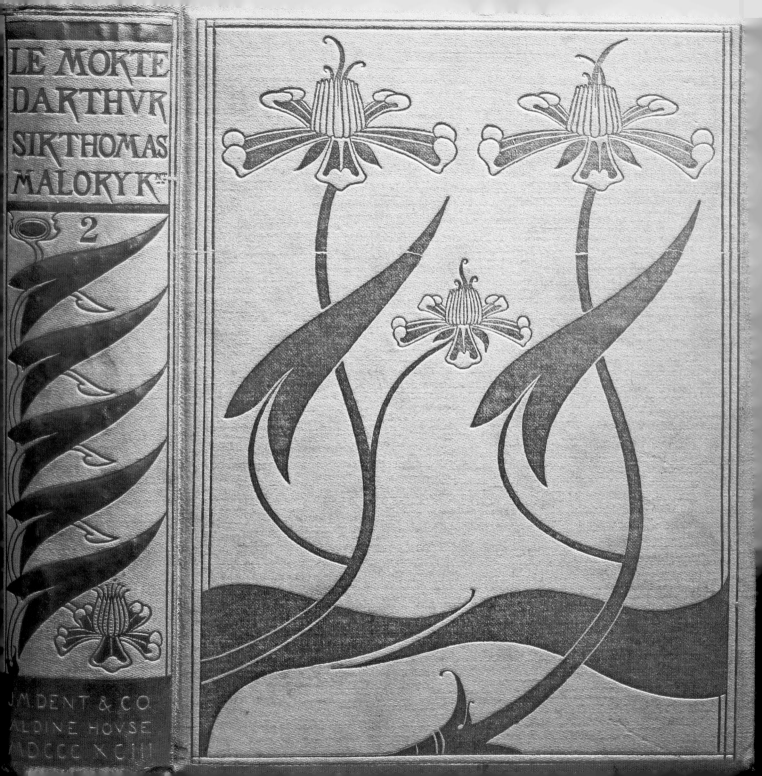

enough to whip'. While she may only have been joking, her temper had been roused by Beardsley's affect insouciance. The fact that her twenty-one-year-old son now owned the roof over her head cannot have made their relationship easier.

In between commissions for posters, book frontispieces and decorations, Beardsley did, in fact, creditably finish the *Morte Darthur*, although his invention flagged as the project neared comp-letion, and some designs were surreptitiously used more than once. But every new draw-ing had had to be 'wrung from him by threats and promises and entreaties', and Aymer Vallance was not alone in noticing a dis-turbing trait in Beardsley's char-acter: a tendency to become dis-couraged through boredom. It worried him.

Aubrey himself was not worried. By the end of 1893, he had not only established himself as one of the pre-emi-nent illustrators of his day, but had also, by virtue of his hard, brittle charm and carefully maintained affectations and fopperies, become a 'character' on the London artistic scene. People were fascinated as much by his youth as by his talent, and in regular interviews to newspapers he played up to the myths with which he

Beardsley by Max Beerbohm. Max's caricatures of Beardsley are always dominated by the artist's graceful hands. (The Bridgeman Art Library / Courtesy Eva Reichmann / The Stapleton Collection)

Cover and spine of the deluxe edition of the Morte Darthur. *(The Bridgeman Art Library / Private Collection)*

was beginning to surround himself – for example that he could only draw using a special gold nib, at night, in the light afforded by two large ormolu candlesticks. He also took particular pleasure in mocking his feeble constitution, proclaiming him-self to be 'so affected, even my lungs are affected.' He began collecting a sheaf of press cut-tings about himself and his work, recommending, in 'reg-ular egotistical letters' (his own phrase) that his friends look out for them.

If not everyone liked Beardsley, no one could ignore him. Some of his notices were positive; most were not – but he determined to rejoice alike in notoriety and praise. When the magazine *Public Opinion*, for example, said that his drawings 'do not belong to the sane in body or mind…' and that 'men of robust intellect or healthy moral tone' would not approve of them, Beardsley told Ross how delighted he was to be set down 'as belong-ing to the Libidinous and Asexual School'. To be exco-riated was to have 'arrived', and Aubrey was too young to know the dangers of having a reputation.

Beardsley found himself celebrating the New Year of 1894 with his friend Henry Harland, an amiable, slightly rumpled thirty-three-year-old writer described by Beerbohm as 'the most joyous of men and the most generous of critics'. Harland was

Henry Harland, 'the most joyous of men and the most generous of critics'. He 'hated to talk of anything about which he couldn't be enthusiastic.' (Hulton Getty)

beloved by a wide and varied circle of friends, drawn from every camp of artistic and literary society, from 'Jemmy' Whistler to Rudyard Kipling and his idol Henry James, all of whom regularly attended the salon of his wife Aline.

Like Beardsley, Harland suffered with tuberculosis – the two had met years before, perhaps even as early as 1891, in the waiting-rooms of Symes Thompson, the specialist whom they shared. Harland enjoyed self-mythologizing almost as much as Beardsley himself, and a warm, unlikely friendship had grown up between them.

As they sat together that New Year's morning in

'one of the densest and soupiest and yellowest of all London's infernalest yellow fogs' – fogs which played merry havoc with their diseased lungs – both men found themselves longing for a new and engrossing project, as Harland would later recall:

> We declared to each other that we thought it quite a pity and a shame that London publishers should feel themselves longer under any obligation to refuse any more of our good manuscripts.
>
> ''Tis monstrous, Aubrey,' said I.
>
> ''Tis a public scandal,' said he. And there and then we decided to have a magazine of our own.

It was thus that *The Yellow Book*, the publication which came almost to define their age, was born. They worked out the details with prodigious speed. The title was Aubrey's idea, suggesting, he thought, 'the ordinary French Novel' and 'advanced' Parisian periodicals like the *Revue Blanche*. *The Yellow Book*, they decided, would contain the best literature and the best art of its time, but at Beardsley's insistence 'Art' would remain independent of 'Literature': there would be no 'illustrations' as such.

It was indeed to be a real book, bound in boards and cloth. This, it was hoped, would persuade more weighty writers and artists of the day to contribute. For all that, *The Yellow Book* should still 'sound the note of bright young defiance', as Henry James put it, always aiming to promote those who found little outlet for their talents in the more august periodicals. And despite 'its constitutional gaiety it was to brave the quarterly form, a thing hitherto of austere, of aweful tradition'.

The following day Beardsley and Harland put

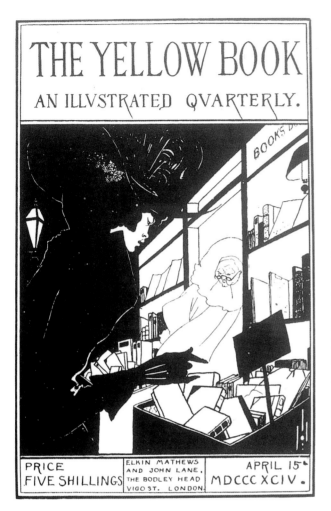

Design for the Prospectus *of* The Yellow Book. *The pierrot in the doorway of Lane's Vigo Street shop is said to be based on Elkin Mathews, Lane's partner. (Mary Evans Picture Library)*

their proposition to John Lane over lunch at the Hogarth Club. Lane instantly recognized that, apart from its own intrinsic merits, such a periodical would be a useful vehicle for promoting his own authors and imprint, and took just five minutes to agree to back it. By the end of lunch, the future of *The Yellow Book* was secure: Beardsley and Harland had a publisher, a publication date, and soon the promise of their first contribution, from no less a figure than Henry James.

In his patronage of *The Yellow Book*, Lane gave sound practical guidance. He knew only too well that in the eyes both of publishers and – more importantly in those morally cramped Victorian days – of the public, indecencies and blasphemies would put Beardsley beyond the pale, and cast him in the light of being a mere pornographer. In the final reckoning, Lane had censored Aubrey's *Salome* illustrations not simply out of prudishness, but from a realization that, while a little notoriety could not hurt a promising artist – *vide* the success of Oscar Wilde – a large amount of it would. And Beardsley, though with a show of reluctance, was persuaded to concur, for he took the venture very seriously. It would, he believed, be the making of his fortune.

In the event, difficulties were made over only one drawing, *The Fat Woman*, a thinly-veiled caricature of Whistler's wife Beatrix Godwin, which Beardsley hoped would enrage 'Jemmy' enough to provoke a reaction. Lane sent the drawing straight back to the artist, whereupon Beardsley feigned outrage: 'I shall most assuredly commit suicide,' he threatened; 'I shall hold demonstrations in Trafalgar Square, and brandish a banner bearing the device "England expects every publisher to do his duty".' Eventually, however, he gave in, and offered the picture to Jerome K. Jerome's magazine *To-Day*, where it was published in May without attracting significant opprobrium – or, it would seem, the notice of J. M. Whistler.

Oscar Wilde's *Salome* finally went on sale in February, compromised but still extraordinary. An immediate popular success, despite its high price, it had a cool reception from the critics. As Wilde had feared, most of the reviews paid scant attention to his text, instead concentrating their fire on Beardsley's illustrations.

Frank Harris's *Saturday Review*, for example, thought Beardsley 'disagreeable', 'derivative' and 'tortured', while *The Times* considered the pictures 'fantastic, grotesque, unintelligible for the most part' and 'repulsive'. Only *The Studio* was prepared unreservedly to praise the book. 'So audacious and extravagant', said its reviewer; Beardsley's drawings acted 'as a piquant maddening potion, not so much a tonic, as a stimulant to fancy'. *Salome* was 'the very essence of the decadent *fin-de-siècle*'.

By the end of March 1894, Lane was loudly announcing that he had advance orders for five thousand copies of *The Yellow Book*, expecting sales to exceed ten thousand. A jolly crowd of contributors, prospective contributors and sundry hangers-on gathered on 15 April, the eve of publication, at a restaurant in Soho. Despite an execrable dinner, it was a gay affair, quite worthy of the bright new book. Very few of the important people were absent – Henry James, Joseph Pennell and one or two others were abroad, James perhaps intentionally so, for he hated crowds almost as much as he frowned on the whiff of 'decadence'. Their absence was not noted so much as that of Elkin Mathews, John Lane's partner at the Bodley Head. Mathews, it transpired years later, had not even been told about the party, for Lane was about to dissolve their partnership.

The following morning, the windows of the Bodley Head offices were filled with copies of the book, 'creating such a mighty glow of yellow at the far end of Vigo Street that one might have been forgiven for imagining that some awful portent had happened, and that the sun had risen in the West!' But the reviewers were not at all pleased with the 'highly-coloured thing'. They criticized 'Mr James in his most mincing mood', loathed Arthur Symons's poem 'Stella Maris', which alluded to a visit to a prostitute, and decried Max Beerbohm's light and delicately satirical essay 'A Defence of Cosmetics' as so much 'pernicious nonsense'. Beerbohm used to reminisce, of the critics' reaction to this his first major piece, that 'if anyone in literature can be lynched, I was'.

For Aubrey Beardsley, however, whose drawings, it was clearly perceived, set the true tone of the magazine, the critics reserved their real venom. The more civil notices dismissed his work as mere 'audacious vulgarity and laborious inelegance'; one reviewer was sure that the cover was 'intended to attract by its very repulsiveness and insolence'. *The Times* thought his drawings 'Japanese sketches gone mad', a revolting 'combination of English rowdyism and French lubricity'. *Punch*, never one to be left on the sidelines of a lynching, weighed in with all the conviction of the moral majority and a double dose of its customary humour:

A poster advertising Children's Books of T. Fisher Unwin, 1894. Beardsley wrote that 'advertisement is an absolute necessity of modern life, and if it can be made beautiful as well as obvious, so much the better for the makers of soap and the public who are likely to wash.' (The Bridgeman Art Library / The Stapleton Collection)

Beware the Yallerbock, my son!
The aims that rile, the art that racks,
Beware the Aub-Aub bird, and shun
The studious Beerbomax!

The *Westminster Gazette*'s reviewer went furthest of all, and earned himself a peculiar and ridiculous immortality by calling for 'a short Act of Parliament to make this sort of thing illegal'.

With the example before him of Whistler and Wilde, who delighted in their worst reviews, Aubrey Beardsley refused to take the malice of such notices to heart, and 'enjoyed the excitement immensely'. He, too, would revel in the mud-slinging, and, just as Whistler and Wilde would have done, attempted to hurl some back. To the critic who attacked his genially mock-bucolic title page as, among other things, a 'decadent' and 'unpardonable affectation', he com-

posed a playful reply, citing a fictitious biographer of Gluck whom he had invented for the purpose:

Let us listen to Bomvet. 'Christopher Willibald Ritter von Gluck, in order to warm his imagination and to transport himself to Aulis or Sparta, was accustomed to place himself in the middle of a field. In this situ-ation, with his piano before him, and a bottle of champagne on each side, he wrote in the open air his two *Iphigenias*, his *Orpheus*, and some other works.' I tremble to think what critics would say had I introduced those bottles of champagne. And yet we do not call Gluck a decadent.

The boy-genius was not, however, always as clever as he thought. During a thoroughly unpleasant review, the *Daily Chronicle* regretted that the announced drawing of

Mrs Patrick Campbell had been omitted from its copy, and Beardsley fell into their cunningly laid trap. He wrote a sharp reply, noting that his picture was present in every *other copy*, which the paper gleefully printed, with a note that the drawing of Mrs Campbell had indeed appeared in their copy, but that they 'rated Mrs Patrick Campbell's beauty, and Mr Beardsley's talent, far too high to suppose that they were united on this occasion.'

The Yellow Book never managed to repeat the massive *succès de scandale* of its first number, which went through three new printings in a week. It continued to attract a high calibre of writer and artist: Lord Leighton was one of the very few who refused to contribute again, after some of his friends told him that he had 'embarrassed serious art', but his place was soon taken by others more willing to be less serious. In its way, it was not unlike a 'trade' magazine of the Decadence, its readership clearly defined and immensely loyal. Over the course of the next year it settled into a solid popular-ity, if never quite respectability.

In the summer of 1894, as the second *Yellow Book* was nearing completion, literary and artistic London gathered at a Hampstead church to celebrate the centenary of the birth of John Keats, the doomed tubercular poet of the Romantic movement. The occasion served, for more than one of the onlookers, as an untimely reminder of the precarious mortality of a 'slender, gaunt young man' whom Haldane MacFall noticed, as the congregation emerged from the church, blinking in the bright light,

> broke away from the throng, and, hurrying across the grave-yard, stumbled and lurched over the green mounds of the sleeping dead. He stooped and stumbled so much, and so awkwardly, that I judged him short-sighted; but was mistaken – he was fighting for breath.

LEFT *The Yellow Book, Vols I and II, 1894. The publication cast its 'mighty glow of yellow' over the artistic life of the entire decade. (The Bridgeman Art Library / Private Collection)*

ABOVE *Original design of the title page of* The Yellow Book, *Vol. I. 'I tremble to think what critics would say had I introduced those bottles of champagne.'*

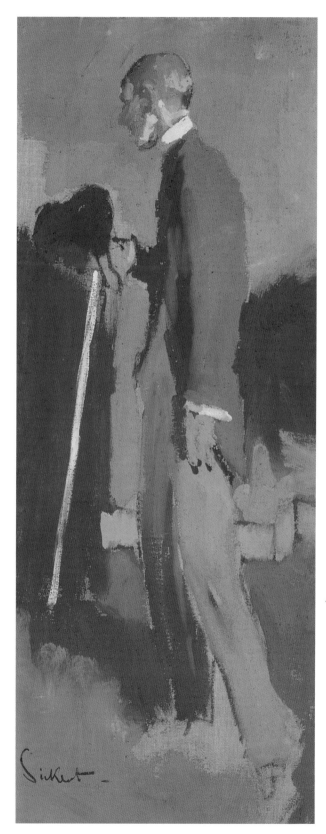

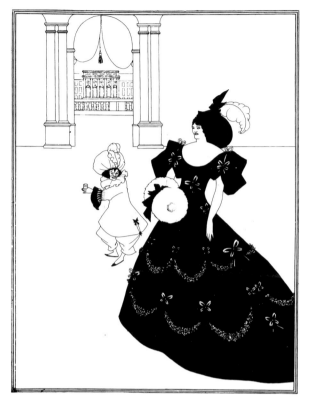

ABOVE No. 1 of The Comedy Ballet of Marionettes *for*
The Yellow Book, Vol II. John Lane did not, it would appear,
notice the suggestive outline made by the swagged curtain.

LEFT *Oil sketch of Beardsley by Walter Sickert. According to the*
critic Heldane MacFall: 'There was something strangely fantastic
in the loose-limbed, lank figure' with his 'pallid, cadaverous
face.' (Copyright Tate Gallery, London / ©Estate of Walter
Richard Sickert, All Rights Reserved, DACS, London, 1998)

The disease in Aubrey Beardsley's lungs was beginning,
little by little, to grow.

Max Alvary and Katerina Klavsky, Wagnerian
singers who had provided the subjects of two of
Beardsley's earliest portraits after a triumphant season at
Covent Garden in 1892, returned to London in 1894 to
perform another round of Wagner operas. Aubrey made
sure to see as much as he could of them and, inspired by

one of their performances, which was so fully attended that the only place he could obtain was on the steps of the aisle, produced one of his most acclaimed drawings, *The Wagnerites*, for the third *Yellow Book*.

One of the operas Klavsky and Alvary performed that season had been *Tannhäuser*, Wagner's rich allegory of pagan sin and Christian salvation. For Beardsley the story struck a chord which was to reverberate for the rest of his short life, and it occurred to him that, since there was no adequate English translation of the story, he would make one himself, and illustrate it. His would be a new treatment of the tale, one which, even more than Wagner's, looked to the mediæval original. An intensely personal treatment, part serious and part satiric, it would 'simply astonish everyone'.

It was easy, at the height of *The Yellow Book*'s success, to persuade John Lane to take the new book, especially since *Masques,* another part-literary, part-illustrated project Beardsley had been working on, had recently fallen through. The Bodley Head's 1894 catalogue of *Belles Lettres* therefore featured a prominent advertisement for the forthcoming publication of '*The Story of Venus and Tannhäuser*, written and pictured by Aubrey Beardsley'. By October, Beardsley was telling friends that his new book would be ready early the next year, 'with a large number of illustrations', most of which, he claimed, were already completed. Throughout the winter, his correspondence is filled with references to the story, and with descriptions of the drawings he claimed to have completed.

The names of Oscar Wilde and Aubrey Beardsley had been associated with each other since Beardsley's very first appearance in the public eye. As early as May 1893, even before the contract for *Salome* had been signed, an Oxford undergraduate magazine had been caricaturing Wilde in Beardsley's distinctive early

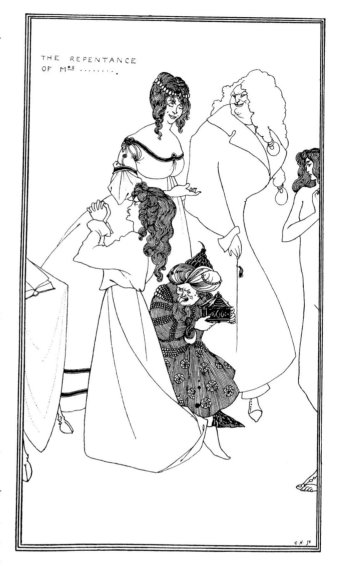

The Repentance of Mrs…, 1894. The influence of the Pre-Raphaelites on Aubrey's portraits of women is at its most evident in this drawing.

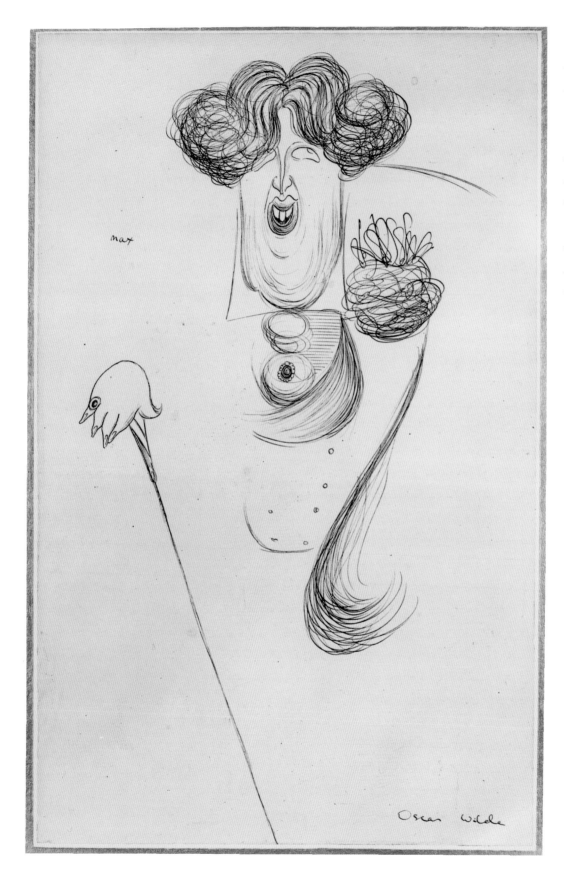

Caricature of Oscar Wilde by Max Beerbohm, 1894. Max later regretted this work, saying that it 'showed only the worse side of Oscar's nature. I hardly realised what a cruel thing it was' until 'Oscar's tragedy and downfall.' (Ashmolean Museum, Oxford / Courtesy Eva Reichmann)

curlicues. Oscar, in his dying years, used to reflect with some justice that it had been his fame which had created the *réclame* of the 'monstrous orchid', with his 'face like a silver hatchet and grass-green hair'. The two men were inextricably associated in the public mind as the leading proponents of the 'decadent' mode of art.

It was a link which, since they both profited from the strength of each other's popularity and reputation, neither was inclined to break. There was never an actual 'rift'; at least publicly, the artist remained on good enough terms with the author, attending the first nights of his plays with all the other fashionable people, and still on occasion lunching with Wilde and his 'court' at the Café Royal. But Aubrey and Oscar had not had a comfortable working relationship: fundamentally, each believed that the world revolved around himself. Wilde would never be invited to contribute to *The Yellow Book*, yet, despite his ostracism, his name could not help but be associated with an artistic movement of which he was widely thought to be the leader.

Oscar's comment on the first number had been uncharacteristically bitter: it was 'dull and loathsome, a great failure. I am so glad.' In one of his impromptu conversational fantasies, however, he was inadvertently prophetic.

I bought [*The Yellow Book*] at the station, but before I had cut all the pages, I threw it out of the carriage window. Suddenly the train stopped and the guard, opening the door, said 'Mr Wilde, you have dropped *The Yellow Book*.' In the cab, with the subtlety of the poet, I cunningly hid it under the cushions and paid my fare... when came a loud knocking at the door, and the cabby appearing, said 'Mr Wilde, you have forgotten *The Yellow Book*.'

As 1894 drew to a close, Wilde's fame was starting to turn into notoriety. His relationship with the aristocratic 'Bosie' Douglas, and his increasingly indiscreet liaisons with rent-boys and street urchins, caused alarm and concern even among his closest friends. Private gossip about his activities was given a wider circulation on the publication in September of a *roman-à-clef* called *The Green Carnation*, which was more than explicit about the activities of Oscar and his '*cénacle*'.

Wilde believed he could afford to ignore the idle gossip of the town. In January 1895 *An Ideal Husband* opened in London to massive and adulatory audiences; a month later, on St Valentine's Day, *The Importance of Being Earnest* opened at the Haymarket. It, too, was an instant success, and the *gratin* made sure to attend. Bosie's father, the Marquess of Queensberry, who violently objected to Wilde's connection with his son, arrived carrying a 'phallic bouquet' of rotten carrots and turnips to hurl at the playwright. At the last minute his ticket was cancelled by the management, and in impotent rage the scarlet Marquess marched to Wilde's club and left his card, which bore the infamous, illiterate libel: 'To Oscar Wilde, posing somdomite'. On Robbie Ross's advice, Wilde took out a suit for criminal libel against the Marquess.

The case came to trial on 3 April, but Oscar was forced to abandon it after three days when he realized that Queensberry was about to produce evidence which would secure not only his own acquittal, but also the prosecution of his accuser. In dropping his case, Wilde had effectively admitted his guilt. That afternoon, after a short delay during which the authorities hoped that Wilde would flee to France, a warrant was issued for the playwright's arrest: Wilde had refused to go, and as the two officers who arrest-

ed him led him away from the Cadogan Hotel, he absently picked up from a table an edition, in yellow wrappers, of Pierre Louÿs's novel *Aphrodite*. A sharp-eyed reporter who saw him hustled into the back of a waiting cab noticed the book in his hand; and the evening newspapers reported:

'OSCAR WILDE ARRESTED.

YELLOW BOOK UNDER HIS ARM.'

That headline, as John Lane used to say, 'killed *The Yellow Book* – and it nearly killed me.' It might yet have survived, had it not been for the presence on Wilde's charge-sheet of the name of Edward Shelley as one of the boys he had 'solicited to commit sodomy'. Shelley, a young man who had been a clerk at Lane's offices, brought the Bodley Head further into the frame.

As Macaulay wrote of the Byron scandal of 1815, 'We know no spectacle so ridiculous as the British public in one of its periodic fits of morality.' In 1895, the British public was convulsed by such a fit. It determined to ensure that no one would escape its indignation. The day after the arrest a jeering, angry mob gathered out-side the Bodley Head's Vigo Street offices, hurling stones through the windows and terrifying the staff.

Lane himself was not in London, but *en route* to New York, where he had extensive business interests. Several cables awaited his arrival there. 'WITHDRAW ALL BEARDSLEY'S DESIGNS OR I WITHDRAW MY BOOKS', wired William Watson, who published at the Bodley Head. Similar messages followed from respectable authors such as Mrs Humphrey Ward, Wilfred Meynell, Francis Thompson and others, with the same demand, and using the same threats.

At first John Lane hoped that he could ride out the storm, and sent an impassioned cable to a London paper, protesting that Beardsley had 'no more sympathy with Oscar Wilde and the vices of the 'Nineties than Hogarth did with the vices of his time'. His efforts were too little, and too late. Lane feared that the Bodley Head could not survive a threatened mass withdrawal of its authors, and he did not in any case have the stomach for the fight.

Frederic Chapman, Lane's deputy in London, was ordered to remove Wilde's books from stock, and to discharge Aubrey Beardsley – as though he had been a mere employee, rather than the man whose artistic vision had come to define an entire movement – from his position as art editor of *The Yellow Book*. Chapman cancelled all Beardsley's drawings from the fifth number, which was within days of issue. The title-page and cover design were replaced by more anodyne designs in his manner; by an oversight only Aubrey's design for the back cover remained to indicate that Beardsley had ever been involved.

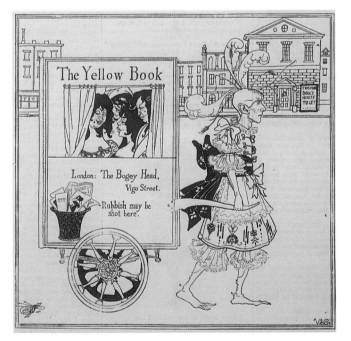

Punch's view of The Yellow Book, *1895. Beardsley took immense pleasure in the hostility of the yellow press. (Mary Evans Picture Library)*

4

'ANYTHING THE OTHERS ARE AFRAID OF'

When the fifth number of *The Yellow Book*, shorn of his work, appeared in late April, Beardsley's conspicuous absence from its pages served only to confirm and re-inforce the popular opinion about Beardsley and the 'vices of the 'Nineties'. The 'oof and fame' which he had once so enjoyed now worked against him. Aubrey began to suspect people of whispering behind his back.

Towards the end of the month, with nothing to keep him in London, and much to make it a bitter place in which to remain, and with Wilde's trial imminent, Beardsley accompanied Henry Harland on an extended visit to Paris.

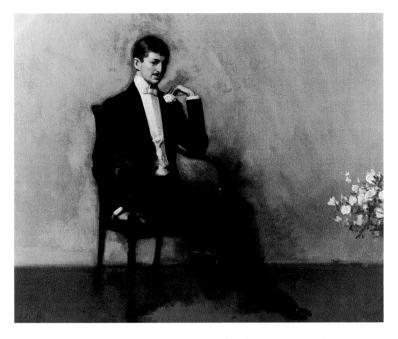

Beardsley's 'Mentor', Marc-André Raffalovich, by Sydney Starr.
'You cannot be Oscar's friend and mine' was his condition.

A fortnight later, however, after Oscar's first trial had concluded in a hung jury and a retrial had been ordered, Aubrey rushed back to England in a panic – the cause of which has never been convincingly established. We only know that, after an exhausting overnight journey to London, he flew to talk to Mabel. She advised him to go and talk to a man scarcely known to either of them.

Marc-André Raffalovich was a Jewish-Russian exile, who had come to England from Paris in 1882, at the age of eighteen. Throughout his life the unkind rumour followed him, that he had been so ugly that his mother could not allow him to remain in the same city as herself. Through lavish hospitality and remorseless social ambition, however, he soon established a sort of position in London society, drawing around him a diverse but charmed circle, including Society figures such as the actress Lily Langtry, Walter Pater, the fashionable academic, and George Meredith, the writer.

Raffalovich had barely the slightest acquaintance with Mabel Beardsley. Although she had persuaded him to attend a 'lecture' on art given by her brother earlier in the year, he had come away from the talk unimpressed by Aubrey and 'without any wish to encounter the Beardsleys again'. His antipathy to Aubrey was almost certainly caused by the implacable hatred he nursed of Oscar Wilde, with whom he had once been close friends. For his part Wilde cordially returned the sentiment, regaling his own circle with stories that Raffalovich had come to London to found a salon, and had 'succeeded… only in opening a saloon'. Raffalovich made it an absolute condition that no friend of his could at the same time continue to be a part of Wilde's circle. When Beardsley arrived at Raffalovich's house in South Audley Street, it must be supposed that, before explaining that he was 'in a fix', he made it clear that there was no love lost between himself and Oscar.

Raffalovich was struck by the young man. 'He arrested me like wrought iron and like honeysuckle; hardness, elegance, charm, vitality.' Some have supposed that it was sexual counselling Beardsley sought – Raffalovich, author of *Uranisme: Inversion Sexuelle Congénitelle*, was an expert both in the practice and the theory of homosexuality; others suggest that Beardsley simply needed money, with which Raffalovich was well provided. Whichever it was, the two struck up an instant, and almost passionate, friendship.

Beardsley, intellectually intrigued though he was by perversity of all kinds, almost certainly never indulged in what would now, for years, be known as Wilde's vice, but Raffalovich seems to have entertained the hope that he could be persuaded otherwise. Aubrey began to receive such a flood of lover's gifts from his new friend – flowers, chocolates, *objets d'art*,

Design for cover of The Yellow Book, *Vol. V. Chapman, Lane's deputy was sure it was 'the most improper thing Beardsley [had] ever done.'*

invitations to dinner – that he was scarcely able to keep up with the volume of thank-you letters he had to write to the man he addressed as 'Mentor'.

It was not a propitious time to press an amorous suit of the kind. An almost tangible sense of apprehension hung in the London air as the world awaited the outcome of the trial. On the boat train which had left Victoria Station on the evening of Wilde's arrest, Robbie Ross counted six hundred men, where normally there would have been sixty. At the end of May, Wilde's second trial concluded with a unanimous 'guilty' verdict, and he was given two years' hard labour, a sentence widely thought to be woefully inadequate. As Jerome K. Jerome, the popular novelist who edited *To-Day* and had enthusiastically solicited Beardsley's drawings only six months before, was calling for the 'heads of the five hundred noblemen and men-of-the-world who share [Wilde's] turpitude and corrupt youth', Beardsley informed Raffalovich of the sentence, remarking with insouciant brutality, 'I imagine it will kill him.'

The Mirror of Love, *1895, a rejected design for Raffalovich's book of poems* The Thread and the Path. *The publisher objected that, whatever Beardsley might say, 'the figure was an hermaphrodite'. (The Bridgeman Art Library / Victoria and Albert Museum, London)*

FAR LEFT *Design for the title-page to* The Mirror of Music, *1895, by Stanley Mackower, including the spine's 'key' motif. Beardsley complained that everyone always found 'their own peculiar meaning in the fall of a festoon, turn of twig and twist of branch' in his designs.*

LEFT *Title page to* At the First Corner, *1895, in John Lane's* Keynotes *series. After Wilde's conviction, Beardsley found it wise to tone down his drawings.*

Many of Beardsley's old friends were puzzled by his lubricious exploits with a new band of acquaintances, a group which included Charles Conder and Ernest Dowson, fabulous drunks and legendary lechers. More than one assumed that Aubrey wished to continue to be spoken of as disreputable – but *conventionally* so. Raffalovich, however, disapproved of the new company Aubrey was keeping, and their friendship, almost as suddenly as it had started, cooled off.

Although by no means destitute, Aubrey found that his sources of revenue were drying up. A couple of old projects needed finishing, and John Lane grudgingly continued to give him piecemeal title pages on the Bodley Head's *Keynotes* series of novels. Beardsley made a frontispiece for Raffalovich's forthcoming book of poems, which the publisher refused to print because he feared it was indecent, and Elkin Mathews, Lane's erstwhile partner, tried to put a little work his way. But a new caution can be seen in Beardsley's drawings, as though he were unwilling, so to speak, to put his head above the moral parapet.

In the wake of Wilde's conviction, John Lane took stock of the list of his Bodley Head authors. On the one hand, he published such solidly respectable figures as Mrs Humphrey Ward and William Watson, whose books sold well and who presented him with no public scandal. On the other was the motley collection of drunken Symbolists and Decadents whose books made him little money and whose bar bills at the Café Royal he was constantly being summoned to pay.

The Oscar Wilde episode had demonstrated to the entire satisfaction of the public that artistic experimentation led inexorably to moral corruption. A choice had to be made, and it is not surprising that Lane chose respectability. Contrary to all the assurances he had made in April, Aubrey Beardsley was not

Leonard Smithers in the early 1890s, before, as it would later be claimed, his life had been 'wrecked by poets'.

Aubrey was particularly anxious to dissociate himself from Wilde. The poet W. B. Yeats recalled Beardsley arriving at his flat after breakfast one morning, 'with a young woman who [would be] called "twopenny coloured". He is a little drunk and… he puts his hand upon the wall, and stares into a mirror. "Yes, yes. I look like a Sodomite. But I am not that."'

retained for the sixth *Yellow Book*, and the various individual members of the Rhymers' Club were gently encouraged to find themselves a new publisher.

Leonard Smithers, a thirty-four-year-old former Sheffield solicitor, rapidly acquiring a name for himself as a disreputable but fearless and highly able publisher, was watching with interest as the Bodley Head purified itself. Smithers, whose pasty face was likened to 'the death mask of Nero', had arrived in London in the late 1880s to work with Sir Richard Burton, the explorer, on a series of translations of the fruitier Latin poets. Unable to find a publisher, Smithers issued the volumes himself under the imprint of the 'Erotica Biblion Society'. After a few years' selling bric-à-brac on Wardour Street, he went into partnership with the printer H. S. Nichols (who was, perhaps, his ex-brother-in-law) and opened a shop in Arundel Street, Strand. Between them, Smithers and Nichols developed a trade in selling prints, books and bibelots above the counter, while from just below it, under a variety of fictitious imprints, they published editions of unusually well-written and well-produced pornography. It was Smithers's boast that he would publish 'anything the others are afraid of'. He had been responsible, in 1893, for *Teleny*, a novel said to have been partly written by Oscar Wilde, and perhaps the most obscene book ever published. He once sold a book allegedly bound in human skin, excusing its very high price with the justification that 'owing to the severe restrictions and prejudices of medical men, it is extremely difficult to obtain portions of dead humanity.'

To bait the authorities, who seemed powerless to stop his activities, he put up a sign in the shop window which read: 'Smut is cheap today'. This kind of behaviour, to respectable folk, cast Smithers as a character beyond the pale – a gross, impudent vulgarian.

W. B. Yeats, who published with him for a while, could not in his *Autobiographies* even bring himself to write out Smithers's name, so bad was the publisher's reputation. But to a few Smithers was a precious, generous friend, and boon companion in times good or bad. Oscar Wilde's pen-portrait says much:

> He usually has a blue tie delicately fastened with a diamond brooch of the impurest water – or perhaps wine, as he never touches water: it goes to his head at once. His face is wasted and pale – not with poetry but with poets, who, he says, have wrecked his life... He loves first editions, especially of women, is the most learned erotomane in Europe, a delightful companion, and a dear friend.

One afternoon in the summer of 1895, Arthur Symons, the poet whose 'Stella Maris' had heightened the air of decadence and scandal which surrounded the first number of *The Yellow Book*, approached Leonard Smithers with the manuscript of his new book of poems which the Bodley Head, as well as several other publishers, had already turned down. To Smithers *London Nights* presented no great difficulty: it was, if anything, rather milder than the books he was used to handling, and he enthusiastically agreed to publish the book.

Smithers realized that Beardsley, after his dismissal from *The Yellow Book*, was a commodity whose stock had fallen, but whose intrinsic value was as great as ever. Many literary and artistic figures, even those who did not personally care for Beardsley, resented John Lane's high-handed treatment of the young illustrator. Smithers also saw that Beardsley had carved out an artistic niche in the market which Lane and Harland were no longer willing to fill. Symons and

Smithers, therefore, decided to set up a rival to *The Yellow Book*.

Symons was sent to sound Beardsley out, and there seemed to be no time to lose. In July 1895, the rumour in London was that Aubrey Beardsley was gravely ill, perhaps even close to death. When he called at Cambridge Street, Symons found the artist, 'horribly white', lying out on the sofa in the studio, whose curtains were drawn to shield him from the light, and thought he had come too late. Beardsley was merely torporific: as Symons described the new project, he rallied immediately, 'full of ideas, full of enthusiasm', brimming over with suggestions for illustrations, themes and contributors. At Aubrey's suggestion the new venture would be called *The Savoy*, after the magnificent new hotel near Smithers's Strand shop.

When Symons had first encountered Beardsley at a gathering of the Rhymers' Club in 1893, he had disliked him: Aubrey was 'the thinnest young man I ever saw, rather unpleasant and affected'. He never really changed his opinion, but decided to overlook his antipathy in the service of Art (and Mammon). Beardsley himself

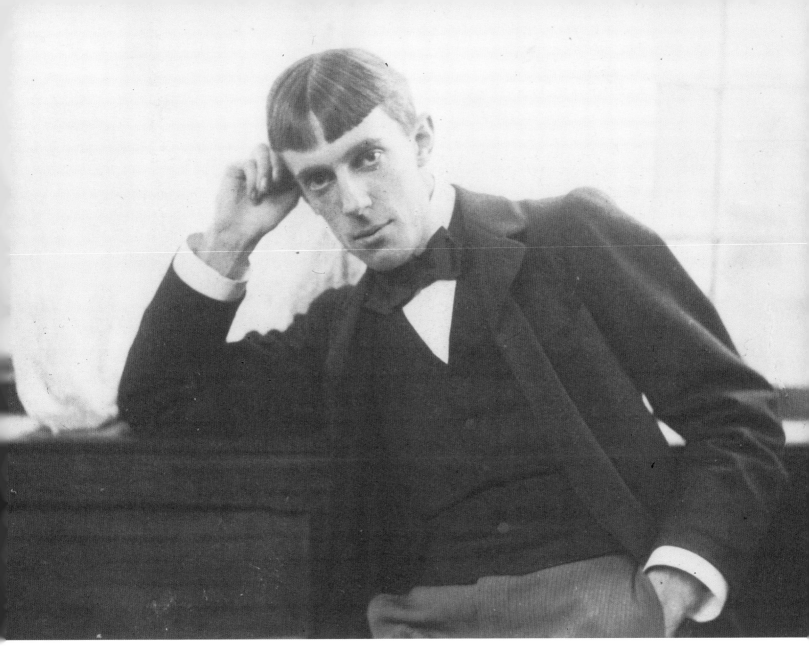

was probably too grateful for the opportunity to get back to work, and at the same time to score over John Lane, to think very hard about the messenger. Reluctantly, in May 1895, faced with an uncertain future, Aubrey and Mabel had decided to sell their house in Cambridge Street. By June or early July, the only house the Beardsley family had ever called their own was sold, and they took a three-year lease on a house in Belgravia. Aubrey did not like it, though, and his lack of attachment soon made itself clear. When one friend sent some fine muslin, Beardsley thanked her, suggesting that it would make a fine suit, 'so nice and cool in this hot weather... If there is any over I shall get some curtains made.' Smithers liked the idea so much that he had an entire ensemble made out of a French furnishing damask, to the horror of his friends.

Meanwhile, Aubrey's imagination was returning to *Venus and Tannhäuser* All had seemed to be going well with the book until the Wilde disaster, when Lane tacitly allowed the project to drop. In the chaos of those first weeks and months,

Aubrey Beardsley in 1895, photographed by Frederick Evans. Beardsley, even more than Oscar Wilde, was intent on creating a 'public image' of himself. (The Bridgeman Art Library / The Stapleton Collection)

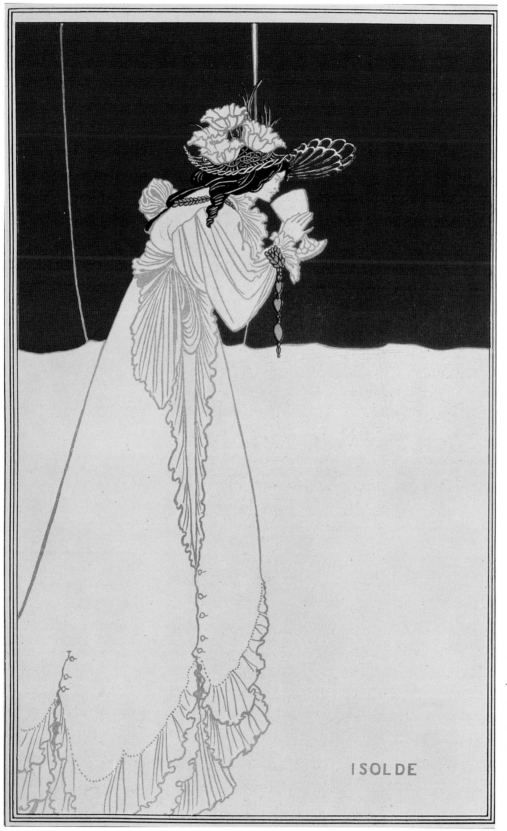

ISOLDE

Isolde, one of Beardsley's favourite Wagnerian characters, in a drawing printed by The Studio *in October 1895. (The Bridgeman Art Library / The Stapleton Collection)*

amid the struggle to get new work and to hold on to those commissions he already had, Beardsley had also let the subject slide. It is now clear that, contrary to his assertions, he had barely begun on his illustrations, and he was probably quite relieved that his bluff had not been called.

Beardsley now saw at first hand how jealously Lane would protect his rights when he tried to offer *Black Coffee*, a picture which had been suppressed from the fifth *Yellow Book*, as a frontispiece to Elkin Mathews, Lane's ex-partner. Beardsley had been under salary from Lane, which meant that the rights to any drawings produced during that time belonged to the Bodley Head. Lane threatened legal action, and 'at the sword's point', Beardsley was made to produce another drawing for Mathews.

As it became clear that John Lane had abandoned him, and that Aubrey's services would not be required for the sixth *Yellow Book*, all the parties must have realized that *Venus and Tannhäuser* was never going to be published at the Bodley Head, for it was exactly the sort of work with which Lane was trying to avoid being associated. Yet even if Lane himself was too pusillanimous to publish the book, he would nevertheless ruthlessly ensure that no one else would.

Smithers was intrigued by Aubrey's novel. While the two men were still on formal, 'Dear Sir' epistolatory terms, Beardsley offered *Venus and Tannhäuser* to

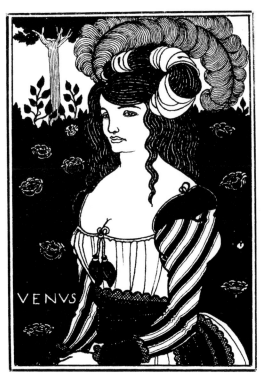

This drawing of Venus was originally intended for the title-page of Lane's Bodley Head edition.

his new champion, suggesting that if they simply renamed his work *The Queen in Exile* Lane would never know the difference. Smithers, however, objected that he would not be able to advertise the book: Lane would immediately, and with some justice, claim it as his own. So, between them, the new partners hit upon a compromise. By changing the title and the names of all the characters, and by publishing it, not as a book, but as a literary contribution to *The Savoy*, when the novel finally came out, it would be too late for Lane to stop them. They hit upon *Under the Hill*, a title whose pun on the *mons veneris* delighted both men, and decided that the first three chapters would be included in the first number of *The Savoy*.

Between illnesses and moves, *The Savoy* took shape at a snail's pace, not helped by the decampment of Symons, Smithers, and many other of the magazine's prospective contributors, to Dieppe, then a slumberous seaside town which was virtually colonized for the summer by artists and writers. In late August Aubrey decided to follow them. Far away from the troubles of London, its slights and apprehensions, Dieppe became a place of freedom, a haven in which he could forget the scandals and *bouleversements* which had dogged the last six months.

It was the 'the first time' he had 'ever enjoyed a holiday', and the fresh sea air exercised its health-

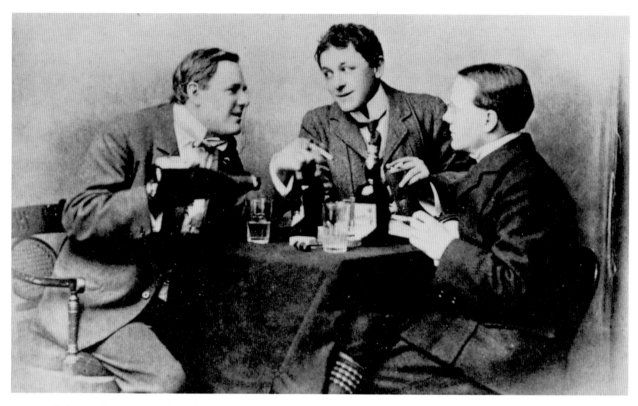

ABOVE (*left to right*): *Leonard Smithers, Ranger Gull and Hannaford Bennett, drinking champagne out of pint glasses.*

BELOW The Bathers, *reproduced in* The Savoy's *inaugural issue as an illustration to Symons's article, 'Dieppe: 1895'*

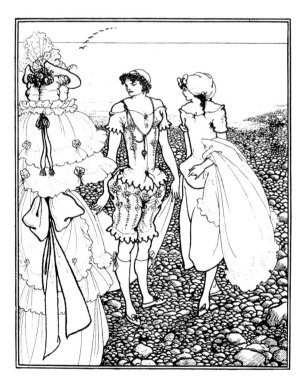

giving influence. Beardsley seemed, at times, as well as he had been for many months. He had not planned to stay for long – a weekend at most – but he 'missed the boat and so stopped on here indefinitely'. Slightly nervous and shy at first, Aubrey hid his nerves by embarking on a comprehensive study of the history of the town. Gradually he allowed himself to join in the high and low life led by Dowson, Conder and Smithers, whose drunken exploits were the amused scandal of the town. At the Casino, he spent hour after mesmerized hour watching the gaming tables and the players, enchanted by the over-gilded decorations, and savouring 'the sense of frivolous things caught at the moment of suspended life', and soon he was telling Symons that he had 'determined to stay here, more or less, for ever'.

At the epicentre of the social life of Dieppe was the painter Jacques-Emile Blanche, whose company provided Aubrey with a welcome antidote to the debauchery of Smithers's circle. Blanche, in his turn, while he did not much care for Beardsley's work, was delighted by the boy's sharp wit and over-civilized manner, and invited Aubrey to sit for a portrait. That marvellous picture, now in the National Portrait Gallery, captures an essence of Aubrey Beardsley, still boyish and playfully dandified, but on the edge of a confident maturity.

Symons and Beardsley toured the country around Dieppe, sightseeing and meeting English and French artists and writers Aubrey had long admired from afar. Blanche provided an introduction to Alexandre Dumas *fils*, the author of *La Dame aux Camélias*, the novel about a courtesan dying of tuberculosis, which had long been a favourite of Beardsley's, and which, indeed, was assuming a talismanic status for him.

The Savoy was discussed incessantly 'amid a great deal of excitement', in cafés and restaurants, and over the *Petits Chevaux*, a species of horse-racing slot-machine at the Casino, until the management threw them out and put up a sign demanding complete silence in the gaming rooms. Every member of the group wanted the magazine to express his own particular idea about art, to what more than one of them thought was Aubrey's 'pompous' annoyance: he was, after all, the 'grand old man' of magazine publishing.

But in mid-September, the various personalities who had done so much to enliven those days in Dieppe began to return to their London lives. Rather than return with them, Beardsley decided to, as he put it, go 'touring all over the world'. There is no record of where, or when, he went, aside from a draft of *Under the Hill*, written on the headed writing paper of a Cologne hotel, and a stray reference much later to a painting that he must have seen in Munich; we only know that he had returned to Dieppe by the end of the month, penniless and without even clean linen, begging Smithers to send clothes and some '*de quoi vivre and quickly*'. In exchange he enclosed his design for the cover of *The Savoy*. It showed a full-lipped 'Beardsley' woman standing in a Palladian landscape, whip in hand, and in the foreground a little *putto* pissing on a copy of *The Yellow Book*: Smithers was delighted by the irreverent detail.

Although it was one of Beardsley's most fondly asserted poses that he could not work anywhere but in his London studio, his time in France had demonstrated that he could do so when required to, and most of his contributions to *The Savoy* were done abroad. He had no desire to return to London, that 'desolate city', but Smithers and *The Savoy* demanded that he come home.

To his surprise, England was not as intolerable as he had feared. There was increased interest in his work – even John Lane appeared to be regretting his behaviour. It was with great pleasure that Aubrey raised his prices for the Bodley Head's new *Pierrot Library*, knowing that Lane would – from a mixture of guilt and sound financial judgement – pay the higher fee.

Nevertheless, money worries continued to hang over him. Smithers gave him a salary, but it was paid erratically, usually in the form of post-dated cheques when funds were available, and Beardsley's idle, peripatetic European summer had been expensive. Aubrey and Mabel had nominally 'lived' at Chester Terrace for barely three months before disposing of the lease at a discount to release their capital. In a show of bravado, Beardsley took rooms at 10–11 St James's Place, an address, formerly occupied by Wilde, which – as the

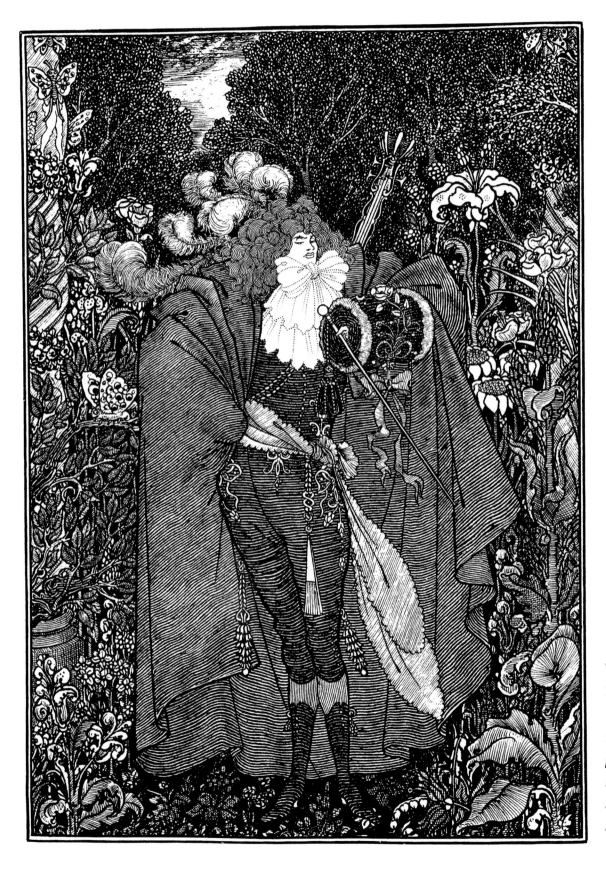

The Abbé
Fanfreluche, *1895.*
'It was taper-time;
when the tired earth
puts on its cloak of
mists and shadows,
and even the beaux
dream a little.'

scene of many of Oscar's bacchanals and debauches — had featured heavily in the May trials.

Without a permanent address, and still dreaming that he would exile himself to France, Beardsley's precious library, repository of so many of his dreams and so much history, was consigned to Smithers for sale. Apart from his extensive wardrobe of clothes, these books were his only possessions, and he found the loss hard to bear.

Although Beardsley had long been telling friends that his *Venus and Tannhäuser* was almost complete, by the middle of 1895 he had in reality hardly written a line, and only completed two designs for the endpapers and a vignette of Venus in Renaissance costume. Neither, significantly, would be used in the work as eventually published. With the constraints of respectability imposed by the Bodley Head no longer upon him, he embarked on the text and its illustrations in a new and bold style. The sultry, spare, and somewhat brooding atmosphere of those early drawings has been replaced by an absolute over-elaboration. His portrait of Tannhäuser, temporarily renamed the 'Abbé Fanfreluche' in *The Savoy*, is one of the most complex and accomplished drawings he ever made. The Abbé,

Prospectus *to* The Savoy, *No. 1, 1895. Unlike John Lane, Smithers loved Beardsley's improprieties and encouraged the artist to be outrageous.*

quite dwarfed by his rich costume, stands at the threshold of the Venusberg, which 'waved drowsily with strange flowers, heavy with perfume, dripping with odours'. Around him flutter 'huge moths, so richly winged they must have banqueted upon tapestries and royal stuffs'. Art and letters in perfect, intricate and inseparable union.

By 9 December *The Savoy* was ready to be sent to the printers, and Symons began to compose his 'Editorial Note'. It acknowledged the change in the *Zeitgeist* since Wilde's fall: the time in which artistic experimentation was welcomed had passed. 'Good work is all we offer our readers', he wrote. 'We have no formulas... We have not invented a new point of view... We are not Realists, or Romanticists, or Decadents. For us, all art is good which is good art.'

There were a few teething troubles to be overcome. On reflection, Smithers decided not to tempt Fate or the fury of John Lane, and reluctantly made Beardsley alter his original cover design, deleting the representation of *The Yellow Book* and the genitals of the *amor*. More serious trouble threatened over the *Prospectus*. The first version had been of a winged pierrot announcing the magazine, but Smithers

Front cover of The Savoy Prospectus, *1895. It was replaced, for the reprint, at the insistence of George Bernard Shaw by a similar design 'of a more tepid temper'.*

objected to it as a poor advertisement for their venture: it was not exciting enough for 'John Bull'. Beardsley took Smithers at his word, and produced a new drawing, with John Bull himself advancing across a stage, in his breeches, his 'excitement' visibly exhibited.

It satisfied Smithers's taste for controversy. As many as eighty-thousand copies had been printed and distributed when one of *The Savoy*'s prospective contributors – perhaps George Bernard Shaw or George Moore – noticed Beardsley's 'silly and blatant vulgarity'. A deputation of authors arrived at Arundel Street demanding that the *Prospectus* be withdrawn. To their

amazement, Smithers, after no more than a token show of reluctance, yielded the point, and agreed to get a new design 'of a more tepid temper'. Later they discovered that he had already distributed the entire stock, and had been about to order a reprint in any case.

The first issue of *The Savoy* was finally published on 11 January 1896. The previous evening, Leonard Smithers had treated a select band of his contributors to a sparsely attended and overwhelmingly masculine dinner in private rooms at the New Lyric Club. Apart from Smithers, Beardsley and Symons, only W. B. Yeats, Max Beerbohm, a long forgotten poet called Roudolf Dircks, and Alice Smithers, the plain but ever good-tempered wife of the publisher were able to attend, so it was an intimate and somewhat muted, though, since it was hosted by Smithers, hardly sober gathering.

The party opened nervously, as though no one was entirely sure of why they were there. To liven up proceedings, Arthur Symons read aloud from two slanderous letters recently received by his friend Yeats, which denounced the new periodical, condemned it as 'the Organ of the Incubi and Succubi', and criticized Yeats for lending his name to so disgraceful a venture. As Smithers, emitting shouts of 'I will prosecute the man', danced around the room trying to wrest the letters from Symons's hand, Beardsley quietly approached Yeats. Although, he confided, he might well have been wounded by such insults, he was not hurt at all. Indeed he rather agreed with Yeats's correspondents: 'All my life I have been fascinated by the spiritual life,' he declared, but despite all, one could only follow one's destiny. And after all, he said, 'there is a kind of morality in doing one's own work when one wants to do other things far more.'

Such talk was too much for Yeats. Morbidly obsessed by spiritualism in all its multifarious incarnations – Hermeticism, Theosophy and, most recently, Diabolism – he dragged Aubrey into a corner of the room and harangued him 'in deep, vibrant tones' with an elab-orate disquisition on the lore and the rites of '*Dyahbolism*', assuming, as Beerbohm recalled, that Aubrey 'was a confirmed worshipper in that line'. Beardsley, who had not the first real interest in the occult, was either too amused or too polite to correct Yeats's misapprehension, and listened patiently, brightly interjecting, from time to time, cries of 'Oh really? how perfectly entrancing!' and 'Oh really? how perfectly sweet.'

The dinner proved taxing for Aubrey's health. When the party reconvened, after dinner, at the flat above Smithers's shop, he was seized by an attack of blood-spitting, and when Yeats arrived, he found the illustrator, 'grey and exhausted, propped up on a chair in the middle of the room'. Aubrey had not finished his fun, nevertheless, and despite his agonies was determined to extract some more entertainment at Smithers's expense. 'Our publisher', Yeats recalled, 'perspiration pouring from his face, was turning the handle of a hurdy-gurdy piano.' Beardsley, rapt, 'pressed him to labour on', murmuring 'the tone is so beautiful', and 'it gives me such deep pleasure'. The evening drew to a late close, a mixture of tragedy and farce.

The Savoy No. 1 is an enduring tribute to the unwearying effort, and the percipient taste, of the three men involved. Where *The Yellow Book* had rarely boasted, for all its two hundred or more pages, work by any more than one or two less-than-transiently famous hands, *The Savoy* contained a roll-call of Nineties talent. Apart from Aubrey's own clutch of contributions to the 'Art', there were pictures by

W. B. Yeats, who coined the phrase 'the Tragic Generation' for his fellow writers and artists of the 1890s for their seeming propensity to die young and unhappy.

Whistler and Walter Sickert, Max Beerbohm's caricature of his famous brother, the actor-manager Herbert Tree, and drawings by Jacques-Emile Blanche, Charles Shannon and Joseph Pennell.

'Literature' was equally strong: poetry by W. B. Yeats and Ernest Dowson, and a Symons translation of Verlaine; essays by Max Beerbohm, G. B. Shaw, Joseph Pennell and Havelock Ellis. There were also, of course, the first chapters of Beardsley's *Under the Hill*, preceded by a mock 'Epistle Dedicatory', with three illustrations. Apart from *The Abbé*, there was *The Fruit Bearers*, a design of dense chiaroscuro and menacing atmosphere, and the delicate *Toilet of Venus*, into which Beardsley introduced the character of Mrs Marsuple, Venus's 'fat manicure and fardeuse'. 'Her voice was full of salacious unction; she had terrible little gestures with the hands, strange movements with the shoulders, a corrupt skin, large horny eyes, a parrot's nose... and chin after chin.' The resemblance to Oscar Wilde would have been unmistakable even without the wicked caricature which appeared in the accompanying picture.

Under the Hill was not the only evidence of Beardsley's literary bent, for he also included 'The Three Musicians', a poem about seduction and scandal among bohemians he had written at Dieppe during the summer. Symons accepted it because it was accompanied by an illustration, but reluctantly. His private verdict was that Beardsley had 'succeeded in doing what he certainly had no aptitude for'.

The contributors themselves were ecstatic about *The Savoy*. Ernest Dowson thought it 'licked *The Yellow Book* hollow', and was a worthy successor to Lane's greying periodical. More surprisingly, *The Savoy* was also generally well received in the press. *The Sunday Times* found much to praise, both in the art and the literature, and recommended the magazine to its readers as '*The Yellow Book* redeemed of its puerilities'. *The Times* praised Beardsley's 'composition, his pattern, his idea'. Even *Punch* was prepared to give *The Savoy* a break, and agreed to publish an amiably witty satirical review by Ada Leverson, one of Beardsley's closest female friends. Only the *Star* found anything much to criticize in *The Savoy*, and even then could not be persuaded to go beyond dismissing it as 'dull... eccentric and insipid'.

Cover design for The Savoy: Complete in Three Volumes, *which Smithers issued at the end of 1896.*

5

'EVEN MY LUNGS ARE AFFECTED'

The furore which Smithers and Beardsley must have expected – would even have welcomed – failed to break. The world refused any longer to be shocked by the so-called Decadents. Having tasted the blood of Oscar Wilde, the public were already finding that a bitter taste remained in the mouth. Max Beerbohm had already noticed the changed mood at the end of the previous year. In 'Diminuendo', his famous mock-valedictory essay, he remarked that the era of Decadence was over. Scandal was 'a trifle outmoded'; the future belonged to 'younger men with months of activity in front of them'. It was the end of the 'Beardsley Period'.

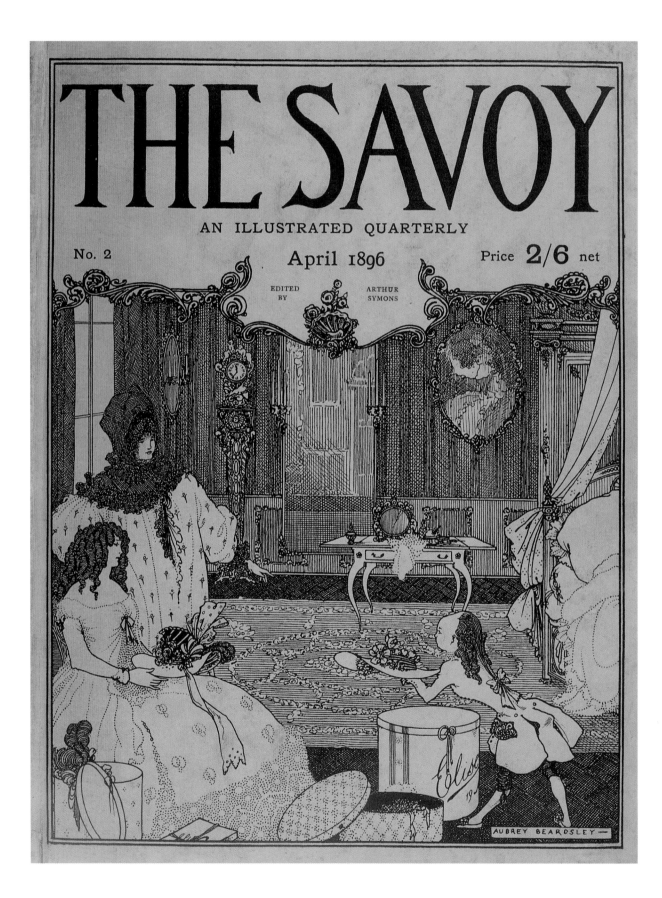

Aubrey Beardsley himself might have profited from the change, had he only lived to his full span. His art was acquiring a new maturity and confidence, and he was beginning to put aside some of the affectations which so annoyed his critics. But while his reviews were improving, his health continued to deteriorate.

In the heyday of *The Yellow Book*, when nothing seemed impossible, and every avenue seemed to be open to him, Beardsley had discussed his future with the writer Edmund Gosse. Gosse advised him not to waste his talent on making frontispieces and decorations for inconsequential writers and the 'ephemeral

works of the day'. Instead of illustrating fripperies, Aubrey should turn his powers to 'acknowledged masterpieces of English literature', carefully chosen to match his own style.

'In his eager, graceful way', Beardsley asked for an example. 'Set me a task,' he begged; 'Tell me what to do and I will obey.' Gosse recommended three works: Ben Jonson's *Volpone*, Congreve's *The Way of the World*, and Pope's *The Rape of the Lock*. It was percipient of Gosse. These mannered, lightly satirical comic texts, the silver-gilt masterpieces of their respective authors, were ideally suited to Beardsley's quicksilver wit and artificial temperament, but he was not, then, ready for them. *The Way of the World* was the only one he 'saw', and although he promised Gosse to strike out immediately, nothing came of it.

While he was paying Aubrey's salary, variously estimated at between ten and twenty pounds a week, Leonard Smithers was naturally anxious to get as much work as he could out of his 'star' illustrator. Aubrey too longed for an absorbing major project to which to dedicate himself. Back in December he had written wistfully to Raffalovich, once again, if cautiously, a friend, 'I wish I had illustrated a book recently!'

As the inaugural *Savoy* was being put to bed, Smithers suggested that Beardsley picture Aristophanes's bawdy play *Lysistrata*, an idea which appealed to him very much. In the middle of December,

FAR LEFT Choosing the New Hat, *1896, front cover of* The Savoy *No. 2. Beardsley insisted that the 'creature handing hats is* not *an infant but an unstrangled abortion.'*

LEFT *Edmund Gosse by John Singer Sargent. A prolific author, Gosse appointed himself mentor to many young writers of the period. (Courtesy National Portrait Gallery, London)*

Aubrey claimed that his first drawing was almost ready: then he lost interest, and for the moment nothing more was heard of it. His mind wandered back to Gosse's 'tasks'. Now it was *The Rape of the Lock*, Alexander Pope's rococo masterpiece, which he 'saw'. Leonard Smithers, who seems instinctively to have understood Aubrey's capricious nature, encouraged him to proceed with all speed on an illustrated edition. There were one or two false starts but, at the beginning of January, Beardsley had the bit between his teeth, and was working steadily.

As work proceeded, Beardsley knew, in all modesty, that his new drawings were among the most extraordinary things he had ever done. Using a development of the style he had invented for *Under the Hill* – at the same time simplified and elaborated – and influenced by French engravings of the eighteenth century, the pictures, with their economy of line and assured use of simple decorative effects to create luxuriant results, were the perfect compliment to the delicate but razor-sharp wit of Pope.

One afternoon Beardsley took his portfolio to Joseph Pennell, to obtain, as he often did, his first critic's encouragement and advice. He trusted Pennell's taste explicitly. Normally shy about showing work-in-progress to any but his very closest friends – to the

Cover design for The Rape of the Lock, *1896. This staggeringly bold design was printed in gold on a turqoise-blue cloth.*

extent that he would often refuse to acknowledge that he was working on anything – Aubrey always welcomed Pennell's criticism. To his surprise, Beardsley found Whistler installed in Pennell's drawing-room, and, to the even greater astonishment of his hosts, he was for the first time unabashed by the presence of the great man. So confident, indeed, was he of his new drawings, that without waiting for Whistler to leave, Aubrey boldly opened his portfolio and passed around his new work. As Pennell remembered:

Whistler looked at them first indifferently, then with interest, then with delight. 'Aubrey – I have made a very great mistake – you are a very great artist.' And the boy burst out crying. All Whistler could say, when he could say anything, was 'I mean it – I mean it – I mean it.'

Beardsley's affection for France and its culture dated back to his boyhood, and was reinforced by the generosity and respect that his fellow artists in Paris and in Dieppe had always accorded him. London, on the other hand, was nothing but a 'filthy hole', where he got 'nothing but snubs and the cold shoulder'. Furthermore, with Smithers an almost constant visitor to the Continent on trips to buy stock, Beardsley realized that he could work on *The Savoy* as easily in

Poor Folk *by Fyodor Dostoievsky, and*
The Dancing Faun *by Florence Farr, both*
designed by Beardsley. His faun is yet another
caricature of Whistler. (The Bridgeman Art
Gallery/Private Collection)

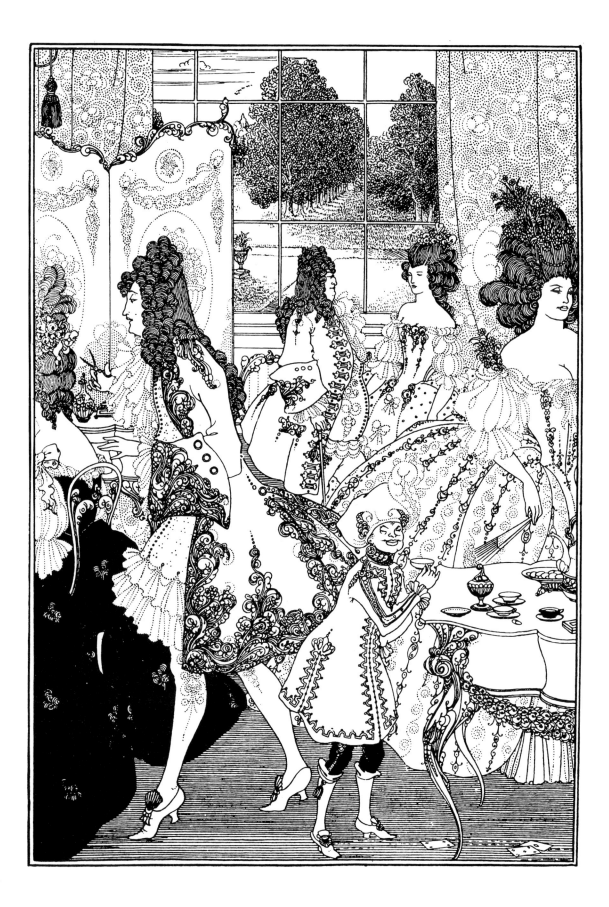

Paris as in London. Thus, early in February 1896, he crossed the Channel and took rooms at the Hôtel St Romain on Rue St Roche. He was there by the eleventh of the month at the latest and, with Ernest Dowson, attended the opening night of the first ever production of Oscar Wilde's *Salome*. To Aubrey's satisfaction, the French press made great play of his presence at the performance, regretting that Beardsley had not himself designed the set and the costumes.

Beardsley, Dowson and Smithers cut a merry threesome, and together spent much time frequenting the less salubrious parts of Paris. On one occasion, while at a restaurant with the journalist Gabriel de Lautrec, Beardsley decided to experiment with hashish. The effect on his feeble constitution was marked. His 'laughter became so tumultuous that it infected the rest of us – who had *not* taken hashish, and we all behaved like imbeciles…' wrote Dowson. 'Luckily we were in a *cabinet*, or I think we would have been turned out.' Not surprisingly, Beardsley's health was not improved by the company he was keeping. *The Cave of Spleen* for *The Rape* 'was completed amidst the distraction of toothache and diarrhoea'.

After Dowson's and Smithers's departure in the middle of the month, however, Aubrey religiously avoided the 'boresome people' who pressed him with invitations and their society. Yet life in Paris suited him well, he found it easy to work, and planned 'to stay a deuce of a time'. Although he was being 'hideously overcharged', he had once again come to the conclu-

LEFT The Rape of the Lock, *1896.*

'The peer now spreads the glitt'ring forfex wide,
T' inclose the lock; now joins it, to divide.
The meeting points the sacred hair dissever
From the fair head, for ever, and for ever!'

sion that a '*solitaire*' existence in France was infinitely preferable to the public cuts and slights of London.

By 12 March, *The Rape of the Lock*, 'with meticulous precision and almost indecent speed' was completed, and the last illustration, *The Battle of the Beaux and Belles*, was consigned to Smithers in London. Beardsley returned to the 'dreadfully hard work' of *The Savoy*'s second number, but his solitude was interrupted by the reappearance in Paris, only a few days later, of his publisher. Smithers managed to fit in a 'couple of days of fun' with Beardsley before he had to leave for business in Brussels; Aubrey went to the Gare du Nord to see him off and, as if on a mad impulse, decided there and then to accompany Smithers to Brussels, taking nothing but the clothes he stood up in.

It was a rash decision, more than probably motivated by his unpaid bill back at his hotel, and it nearly proved to be a fatal one, for almost immediately on arrival there, he was racked by a series of violent haemorrhages of the lung, and forced to take to his bed. Smithers had to return to England, whereupon Aubrey found himself marooned in Belgium, unable to leave his hotel, let alone return to London or even Paris. He was to spend the next six weeks a virtual prisoner at the Hôtel de Saxe. He was without so much as a change of clothes until Smithers managed to get another outfit sent out to him, a little luxury to which the dandy in Aubrey looked forward with an almost pathetic enthusiasm: 'I shall feel a beastly toff when I find myself once more with two suits.'

Smithers reappeared from time to time. On one occasion, with his wife Alice and the American writer Vincent O'Sullivan in tow, the four of them went to the opera to see a performance of *Carmen*. 'Alice surpassed herself, shewing her advantages where she had

them, and a man alone in a box, who looked an important personage, fell for her with a thud.' After the performance, the 'personage' followed the little party to a restaurant, where he continued to gaze awestruck at Mrs Smithers. O'Sullivan had to escort Aubrey 'in his half-invalid state' home, and thus they missed the *dénouement* of the episode: Smithers later claimed to have 'fixed a price' with the man for the enjoyment of his wife.

In the solitary calm of his Brussels rooms, Beardsley did manage to proceed on his contributions for the current *Savoy*, although he warned Smithers not to 'be surprised if you get a mixed collection of drawings – I'm nervous as a cat, and torn in a thousand directions.' In only a few days he had finished his designs for the cover, the contents page, and two drawings for the second instalment of *Under the Hill: The Ascension of St Rose of Lima*, and *The Coiffing*.

The Coiffing was intended to illustrate 'The Ballad of a Barber', the ninth chapter of *Under the Hill* in the second *Savoy*. Beardsley had taken 'infinite pains' over his verse tale of a *coiffeur* who murdered a princess after his 'fingers lost their cunning quite' for desire for her. 'Is not the verse polished?' he preened. To his dismay, Smithers sent word at the beginning of April with the news that Symons had thought the 'Ballad' 'poor' and was refusing to publish the poem.

Aubrey Beardsley and Arthur Symons were always going to have been uneasy bedfellows at *The Savoy*: their aims were such poles apart. To Symons, who looked on poets like Baudelaire and Verlaine as minor deities, Beardsley's light verses would have seemed little more than doggerel. An obligation to include them would, he felt, undermine his serious literary agenda. *Under the Hill* Symons had been prepared to publish – if nothing else, it was in prose. But the 'Ballad' encroached into the realms of Poetry, of which Symons thought himself the king. So Symons had told Smithers to inform Beardsley that the verses, in particular the last one, were 'poor', and that no persuasion would move him to print them.

To Beardsley it rankled

The Death of Pierrot, *1896, from* The Savoy *No. 6. 'As the dawn broke, Pierrot fell into his last sleep. With much love [they] carried away upon their shoulders the white-frocked clown of Bergamo; whither we know not.'*

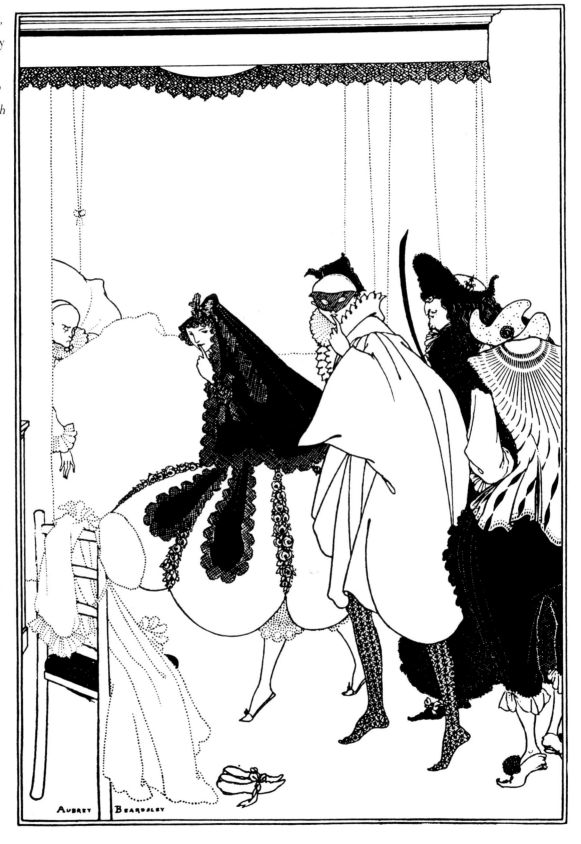

especially that the publisher, and not the editor, had been the bearer of the news. He told Smithers that he was 'horrified', particularly since the omission of the poem and its illustration would leave him 'rather thinly represented in the number'. If it really was poor, he argued, it could of course be printed 'under a pseudonym and separately from *Under the Hill*', teasingly adding: 'What do you think of "Symons" as a *nom de plume?*'

An uneasy compromise was reached: a drawing from *The Rape of the Lock*, rapidly nearing publication, would be substituted for *The Coiffing*, while the 'Ballad' itself, grudgingly rewritten to Symons's requirement, would be included in the third *Savoy*. The arrangement satisfied neither party, and although the difficulties had been diplomatically handled by Smithers, relations between Beardsley and Symons became glacial.

Time passed slowly in Brussels. Forbidden to eat fish or drink wine, Aubrey was denied even the simplest

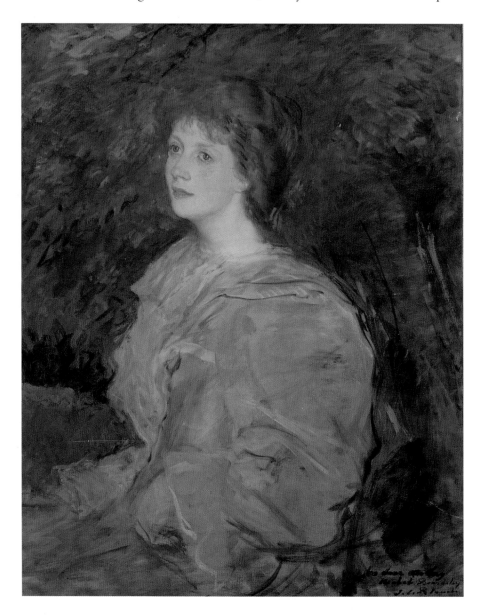

Mabel Beardsley, *1895,*
a far more complex character
than suggested by this
image by J. E. Blanche.
(The Bridgeman Art
Library / Sheffield City Art
Galleries /© ADAGP, Paris
and DACS, London, 1998)

pleasures. Mabel, now a moderately successful second-tier actress, was so worried by the distressing reports about her brother's health – reports which he made sure to play down – that she took time from rehearsals to spend a week with him in Brussels. Her presence, and the naughty lunches of fish and wine they took together, cheered his spirits greatly, but after she had gone, he told Smithers that 'if it wasn't for my work I shouldn't know how to kill my time'. His health a see-saw of relapses and improvements, Aubrey had plenty of time to brood over his treatment at Symons's hands, and began a limerick which he pretended was for *The Savoy*:

There was a young invalid
Whose lung would do nothing but bleed…

adding: 'Symons shall finish it if he is a good boy.'

Money troubles – doctor's bills and hotel fares – were a constant source of worry. The proprietor of the Hôtel de Saxe sensibly made sure to secure regular payment from the cadaverous Englishman who had arrived without luggage and who looked like he might depart, not just the hotel but the world, at any moment.

By keeping quiet and rarely going out, Aubrey's health gradually improved. By the end of the month the doctor was happy enough with his progress to agree that the patient might shortly be well enough to return home. Beardsley cabled to Mabel asking her to 'pilot him over' the Channel, but she could not spare the time from rehearsals; Robbie Ross was approached, but he was also too busy; Raffalovich, who was in Brussels, was on his way to Berlin. Despite her own poor health, it fell to Ellen Beardsley to fetch her son back. She arrived at Brussels on 3 May, but was 'so knocked up when she got there' that their return was postponed for a day or two.

Aubrey and his mother finally returned to London on the fifth, and immediately called on Dr Thompson, whom Beardsley had not seen for more than three months. Thompson put the gravest face on matters: his patient's life was in danger. 'Absolute quiet and, if possible, immediate change' was now the only option. Aubrey began, for the first time in the long course of his disease, to be 'really depressed and frightened about myself'.

There was one consolation: *The Rape of the Lock* was on sale, beautifully printed in a 'limited' edition of a thousand copies. Beardsley immediately and with relish set about circulating his presentation copies. The first and most important went to Edmund Gosse, to whom the volume was dedicated. Gosse was delighted with the 'delicious, golden book', 'truly proud to be associated with such an ingenious object'. It was equally well received in the press.

However clear his doctor's recommendations had been, Aubrey was congenitally incapable of 'absolute quiet'. He had 'too much to do', and the prospect of death only made him more anxious to do it. Having put off the 'change' for as long as possible, under the nagging of his mother, Beardsley finally allowed himself to be persuaded, at the end of May, to retire to a rest-home at Crowborough. The countryside was more depressing than even he had expected, and although the fresh air exercised some beneficial effect, Aubrey stayed only a fortnight before scuttling back to London.

Although Beardsley's tuberculosis was not yet actually terminal, the state of his lungs was very grave, and they had to be carefully nursed. This created its own dilemma: it was important that he put off those to whom he owed work for as long as possible while still securing the sources of his income. On the one

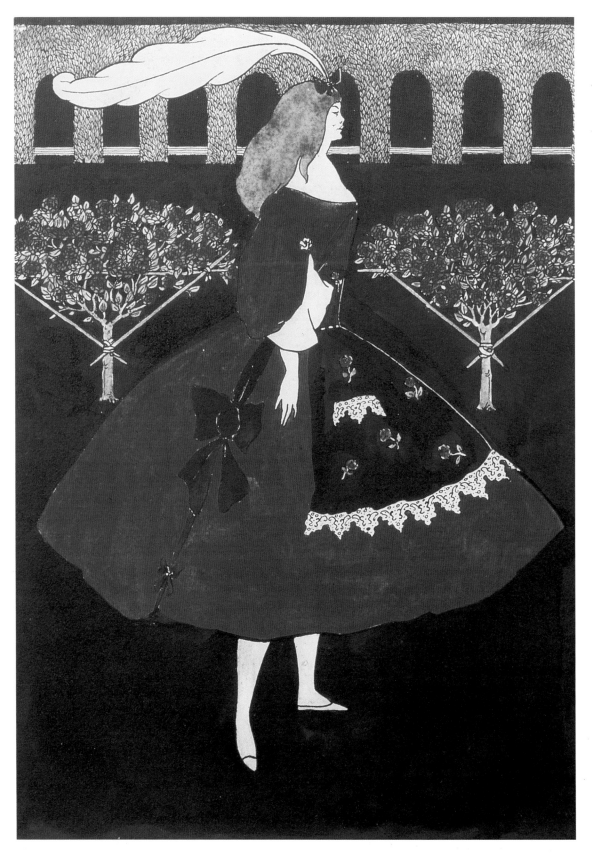

The Slippers of
Cinderella, *1894, first
printed in* The Yellow
Book. *In 1896, the
publishers William
Heinemann commis-
sioned an ambitious
edition of the story,
never completed, for
which Beardsley
coloured his original
design. (The Bridgeman
Art Library / Bonhams,
London)*

hand he wrote to Jerome Pollitt announcing that he had been obliged to stop work altogether, while on the other he underplayed his condition to Smithers, boasting that he would 'be strong enough to kick Symons's little arse' in no time. The reality lay somewhere in between. Aubrey owed Pollitt a long-promised (and long-paid-for) bookplate over which he was dragging his heels; while at the same time, the best possible complexion had to be put on things for his publisher, who continued to send money on a regular basis in anticipation of work. Smithers, though a generous and tolerant patron, could not have afforded to support an illustrator who was unable to work.

Buoyed up by good sales and such promising reports from Beardsley about his health, Smithers announced in its July issue that *The Savoy* would henceforward be issued monthly. The change was ill-advised: still recovering after his Brussels interlude, Beardsley's contributions now slackened off to almost nothing. Further installments of *Under the Hill* were cancelled, and although Symons's 'Literature' continued to sustain a consistently high calibre of contribution, the next four issues of *The Savoy* would contain only the bare minimum of Aubrey's work. He continued to provide designs for the covers, so that he was at least represented in the magazine, but the absence of its chief illustrator undoubtedly deprived *The Savoy* of its defining personality.

The situation was to be made worse when the booksellers W. H. Smith refused to stock the third, and any subsequent, numbers because of the magazine's supposedly 'licentious' character. It was, however, clear to all concerned that their real objection was to Aubrey Beardsley. Symons hurried round to Smith's offices and tried to remonstrate, begging to be shown an example of what they meant. The manager opened

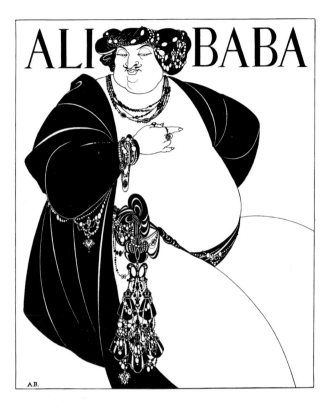

Cover design of Ali Baba and the Forty Thieves, *1896, another book that never came to fruition.*

his copy, and indicated one drawing he found particularly objectionable, whereupon Symons pointed out that the picture was not by Beardsley, but William Blake, 'a very spiritual artist'. Disingenuously they replied that their shops had 'an audience of young ladies as well as agnostics'. Without the co-operation of Smith's, who held a virtual monopoly of bookstalls at railway stations, a large sale would be a virtual impossibility.

The London air continued to do Aubrey's health no good, and at the beginning of July, having thought about going to Brighton, he decided to retire to Epsom, another town reminiscent of his childhood. In a palatial suite at the Spread Eagle Hotel, Beardsley surveyed the abandoned schemes of the past six months, and again settled to work on Aristophanes's *Lysistrata*. In

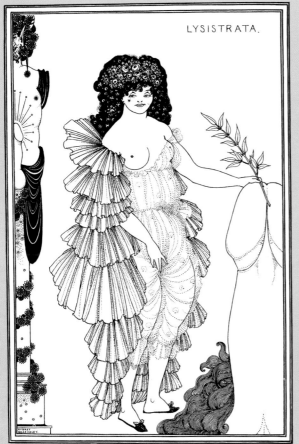

Lysistrata Shielding her Coynte, *from* Lysistrata.
Smithers published Beardsley's drawings in a strictly limited edition in 1896. (et archive)

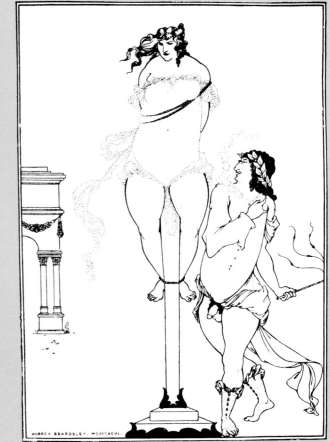

Juvenal Scourging the Women, *from Juvenal's* Sixth Satire.
Juvenal's poem was the inspiration for several pictures, including two of Messalina: 'there were few men at Rome who could not boast of having enjoyed the favours of the impure Messalina'.

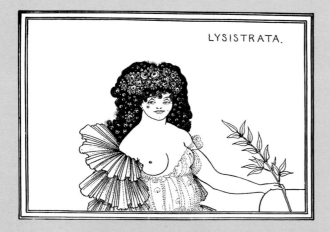

The same drawing, published by John Lane in 1900. Wanting to print Beardsley's designs for Lysistrata, *without incurring opprobrium, when Lane came to publish* The Later Work of Aubrey Beardsley, *he simply 'cut out' Beardsley's improprieties, thus reducing them to adsurdities. (et archive)*

Anonymous nineteenth century Japanese erotic work. Robbie Ross gave Beardsley a book of such pictures, which the artist disbound and displayed on his walls at Cambridge Street until the house had to be sold by Smithers. (The Bridgeman Art Library / The Stapleton Collection)

just three weeks he had completed eight full-page draw-ings of an almost unsurpassed brilliance. Stylistically, they bring together the full range of his techniques – from the early discoveries of vast areas of white page and minimal perspective, to the heavily worked textures of his most recent manner, while thematically, his images of dominant women and frustrated men distortedly reflect his own frustrations in the face of his own body's decay.

On the seventeenth of the month he made his will, naming Mabel as his executrix and sole heir.

Sales of *The Savoy* continued to flag. In October Smithers decided that the eighth (December) issue would be its last. Symons, in his 'Editorial Note', wrote bitterly that, where he had once thought that there were 'many people in the world who really cared for art, and really for art's sake', he was now persuaded otherwise. 'Comparatively few people care for art at all, and most of them care for it because they mistake it for something else.'

Yet Smithers's faith in Beardsley remained unaltered. In the autumn he had the idea of publishing a retrospec-tive collection of 'Fifty Drawings'. In this way, Beardsley would be spared too much effort, while at the same time his name would be kept in the public eye. Aymer Vallance was engaged to write an appreciation, a prospect which aroused mixed feelings in Aubrey. 'Don't,' he begged Smithers, 'let Vallance [make out] that I am forty-five and have been working for fif-teen years,' he begged. A dandy to the last, he thought that the book should 'give people the impression

Count Valmont from Liaisons Dangereuses: *'I have long set my heart on making some pictures for the book.' This was the only design for that book that he finished.*

that I am two, and have been working for three weeks.'

Epsom did not remain congenial for long. His health once again sliding, Beardsley began to think about where to spend the summer. France, he realized, was for the moment out of the question, as his bill at the Hôtel St Romain remained unpaid. 'I have alarming notions of the perfection of the French police system,' he told Smithers; 'I don't believe there is a *gendarme* in France who hasn't my photograph or a model of my prick about him.' Instead he determined on Boscombe, a small town near Bournemouth whose air was supposed to be partic-ularly healthy.

The move proved to be a mixed blessing. Its distance from London, and the consequent lack of social interrup-tion to his convalescence, infuriated him, but the quiet once again inspired prodi-gious amounts of work. Having com-pleted his contributions to the final *Savoy*, which would be made up entirely of work by himself and Symons, Beardsley began to plan out two new books: Juvenal's *Sixth Satire*, for which he man-aged five pictures before inspiration ran out, and Laclos's *Liaisons Dangereuses*.

That, too, fell by the wayside. In December, after four largely peaceful months in Boscombe, Aubrey 'collapsed in all directions'. On a 'walklet' in the Winter Gardens, his lungs began to haemorrhage. He had to be dragged back to the hotel in a donkey chair, leaving a trail of blood to mark his route home. Although, to Smithers, he tried to make light of the attack, saying 'I expected I should make an *al fresco* croak of it,' the laugh was turning hollow.

6

'I LIVE ON THORNS'

Although it was becoming evident that no amount of fresh air would effect a cure, Beardsley put on as brave a face as he could manage. In an interview with the *Idler*, he tried to avoid facing up to the reality of his situation. Having recommended that his interviewer 'lay down a few dozen' of a particularly fine claret, and blithely ignoring the fact that he was doing precisely the opposite of his words, he opined that a man could not 'die better than by doing just what he wants to do most! It is bad enough to be an invalid, but to be a slave to one's lungs and to be found wintering in some unearthly place and sniffing sea breezes or pine-breezes, with the mistaken idea that it will prolong one's existence, seems to me utter foolishness.'

Et in Arcadia Ego
from The Savoy,
No. 8: Even in
Paradise lurks Death;
even the Dandy will
not escape it.

In 'the secrecy of Boscombe', with only the company of his mother to relieve the tedious rhythm of the invalid's life, the energy required for work now deserted him, and Aubrey became more and more depressed. On Christmas day, despondency was temporarily lifted when some children staying at his hotel laid a 'pile of little presents' by his plate, but with no apparent improvement in his health, his mood plumbed such new depths that the doctors believed their patient had quite lost the will to live. Even the commotions of London, it was thought, would be of 'a lesser risk' than remaining at Boscombe. It was decided that Beardsley should for the time being transfer to Bournemouth which, though only a few miles away, was considered to have a better atmosphere, and would help lift his spirits. The day of departure was no sooner fixed, however, than Beardsley suffered another attack, which left him 'hovering between life and death' for a week. At the end of January 1897, fearing that further inaction would see their patient off, the doctors had the half-conscious Aubrey carried from his rooms in an invalid's chair and driven to Bournemouth in a heated carriage.

The move, like all those before it, seemed to be beneficial. Staying at a guest house called 'Muriel',

The Papal Procession on the Feast of Corpus Christi *by Francois Alexandre Villain. Like many others of his period, Beardsley was seduced by the spiritual theatre of the Church of Rome. (The Bridgeman Art Library / Private Collection)*

where he was to spend the next three months, Beardsley regained some of his former *élan*: 'I suffer a little from the name of this house,' he confessed to the poet John Gray, an increasingly close friend, 'I feel as shy… as a boy at school is of his Christian name when it is Ebenezer or Aubrey.' Raffalovich, who had also been keeping in close touch, rallied round with a fresh stream of little presents and flowers. Realizing, too, that the invalid had now no visible means of support, and no way of earning his living, he offered him an allowance, which Beardsley eagerly accepted.

Both Raffalovich, himself Jewish by birth, and Mabel Beardsley had converted to Rome during 1896, and Raffalovich had long been trying to persuade Aubrey to take instruction in Roman Catholicism. As a boy Beardsley had been surrounded by the 'smells and bells' of High Anglicanism, and had always been interested, at least intellectually, in the Church of Rome. Catholicism was the 'fashionable' religion of the Nineties and, as Oscar Wilde used to joke, it was certainly 'the only religion to die in'. For some time Beardsley had been putting Raffalovich off without completely rejecting his advances. His objections were convincing and sincere: quoting Pascal, he argued that the artist's life was incompatible with the religious: 'to become a Christian, the man of letters must sacrifice his gifts, just as Magdalen must sacrifice her beauty.' Almost sheepishly he added, 'I am not very fruitful soil.'

Early in 1897, however, with all work stopped and Ellen being told that her son was unlikely to survive the winter, Beardsley began to take instruction from a local Jesuit. Aubrey made light of his new inclinations to the godless Leonard Smithers, but there seems little doubt that he was sincere in his new-found faith. On 31 March, he was received into the Church of Rome. 'I feel,' he told his new 'brother' André, 'like someone who has been standing waiting on the doorstep of a house on a cold day, and who cannot make up his mind to knock. At last the door is thrown open, and all the warmth of kind hospitality makes glad the frozen traveller.'

Meanwhile, the doctors felt that the English climate was no longer suitable, and advised Beardsley to go to Menton, a well-known invalids' resort in the south of France. It was without regret that he left Bournemouth at the beginning of April, and after two last sad days in London, the city he loved and which he knew he would never see again, Aubrey and Ellen set off for Paris on the tenth of the month, with Raffalovich's doctor, one Phillips, to look after him on the journey.

In Paris Beardsley again rallied. Dr Phillips was 'surprised at the way in which I got through the move', and Aubrey was soon talking walks ('as pertinaciously as a tart') for the first time in four months. Despite the fact that Ellen could not 'abide Paris, and is utterly British over everything', having taken comfortable rooms in a central hotel, Aubrey decided not to go south after all. Menton, he had heard, was so dull that 'but for the occasional funeral there would be no life in the place'. Resuming work was still out of the question nevertheless. To ease his inactivity, and to keep him steady in the faith, Raffalovich sent a steady stream of 'pi' books – Aquinas, St Teresa, and volumes of sermons. *The Rape of the Lock* had proved to be extremely popular, and when Smithers announced plans to bring out a second edition, Beardsley's spirits picked up even more. Despite minor relapses, and constant entreaties for Raffalovich to 'pray for his soul', the will to live returned.

He was still, nevertheless, obliged to 'nurse [his]

new strength with extreme care,' and the idleness this convalescence imposed was infinitely frustrating. 'I live on thorns,' he told Smithers; 'would to God I had done even one piece of black and white work – transcendental or otherwise.' By May, however, he was strong enough to be thinking about new projects. To William Heinemann, who asked for an illustration to a *History of Dancing*, Aubrey suggested a picture of Bathyllus, a character from the *Sixth Satire* of Juvenal on which he had worked the previous year; and he even started to plan for future editions with Smithers. *Mademoiselle de Maupin*, *Ali Baba* and Casanova's 'perfectly stunning' *Memoirs* immediately suggested themselves, and on the first two he made tentative starts.

As the summer approached, on Raffalovich's recommendation Aubrey and Ellen left Paris for the quieter atmosphere of St Germain, a move several times put off because Ellen was intermittently ill. After a

fortnight of 'ominous crepitations', at the beginning of June he was felled by yet another attack of blood-spitting. Lamarre, the comprehensively incompetent local doctor, was bizarrely cheerful. In his opinion, the latest haemorrhage had done Aubrey 'a lot of good' by, as it were, clearing a blockage; Lamarre diagnosed that Beardsley 'could scarcely be called a consumptive at all', and was on the road to a full recovery. Aubrey tried hard to believe in the good news, but drawing was, once again, stopped.

During June, his health started to improve again. Already he and his mother were thinking about where to spend the winter. The French towns of Boulogne and Dinard were rejected as being too expensive, while Menton seemed to be completely forgotten. Dieppe, 'not too fashionable, and I know from experience… amusing and inexpensive' was settled on for the immediate future. They left on 12 July.

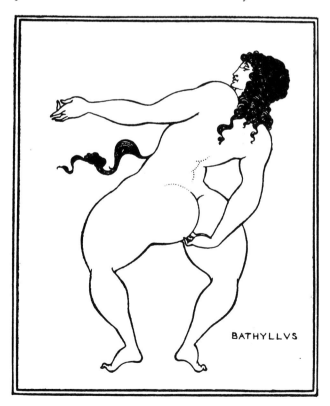

BATHYLLVS

Bathyllus Posturing, *one of Beardsley's drawings for Juvenal's* Sixth Satire. *Aubrey's youthful researches among the more frank items in the British Museum's collection of Greek vases is in clear evidence here.* (The Bridgeman Art Library / The Stapleton Collection)

103

There was a minor hitch at the station: after they had boarded an express boat-train at Paris, the guard tried to remove the party when he discovered that they were not in fact travelling through to London. Ellen insisted on being allowed to take the express, since the next train would take several hours longer to reach the coast, and it was 'only a minute before the train started that we prevailed upon the authorities to break the rule.' Even so, all the heavy baggage had to be left at the station, to be sent on later. Amazingly, the commotion did nothing to break Aubrey's recent run of good health.

With Charles Conder, Blanche and Dowson also in town, Beardsley soon found himself 'leading almost precisely the same life as I did here two years ago – so the past keeps me a sort of cheerful company.' Smithers was an infrequent though welcome visitor, and exercised many little kindnesses, sending any books or pictures Beardsley requested, and on one occasion Beardsley met Serge Diaghelev, then a young ballet impresario who had eagerly looked out the 'leader' of Decadence.

Company of a less 'cheerful' type was provided by the presence of Oscar Wilde, who had been released from prison a few weeks before. He was staying at Berneval-sur-Mer, a village only a few miles from Dieppe, and was going under the name of Sebastian Melmouth. The fanciful *nom d'exil* fooled none of the local tradesmen, who often refused to serve him and he was finding life very trying. While he had expected to be cut by the English tourists, Oscar was finding that the 'freemasonry of artists', many of whom went to extraordinary trouble to insult him, was not after all a very liberal one.

Beardsley saw Wilde once or twice before realizing that Raffalovich would be bound to hear of it, and thereafter he kept his contact to a bare minimum. He was in a difficult position: while Raffalovich was providing him with a generous allowance, Aubrey could literally not afford to provoke the hostility of his patron. Once, while walking in town with Blanche and Conder, he deliberately, ostentatiously, changed course to avoid a public meeting with Wilde; then, having accepted an invitation to dine, he simply did not show up. Oscar was deeply insulted: 'A boy like that, whom I made! No, it was too *lâche* of Aubrey.'

By August, Aubrey was at work once again, for example on drawings for Vincent O'Sullivan's book *Houses of Sin* and at last finishing – although this was kept a close secret from Smithers – his picture for Heinemann's *History of Dancing*. When Smithers suggested that he make a frontispiece to Wilde's new book, *The Ballad of Reading Gaol*, Beardsley eagerly agreed 'in a manner which', Smithers

The Lady with the Monkey, *from* Mademoiselle de Maupin, *which Smithers published in 1898. This design may originally have been intended to illustrate Smither's edition of* Volpone.

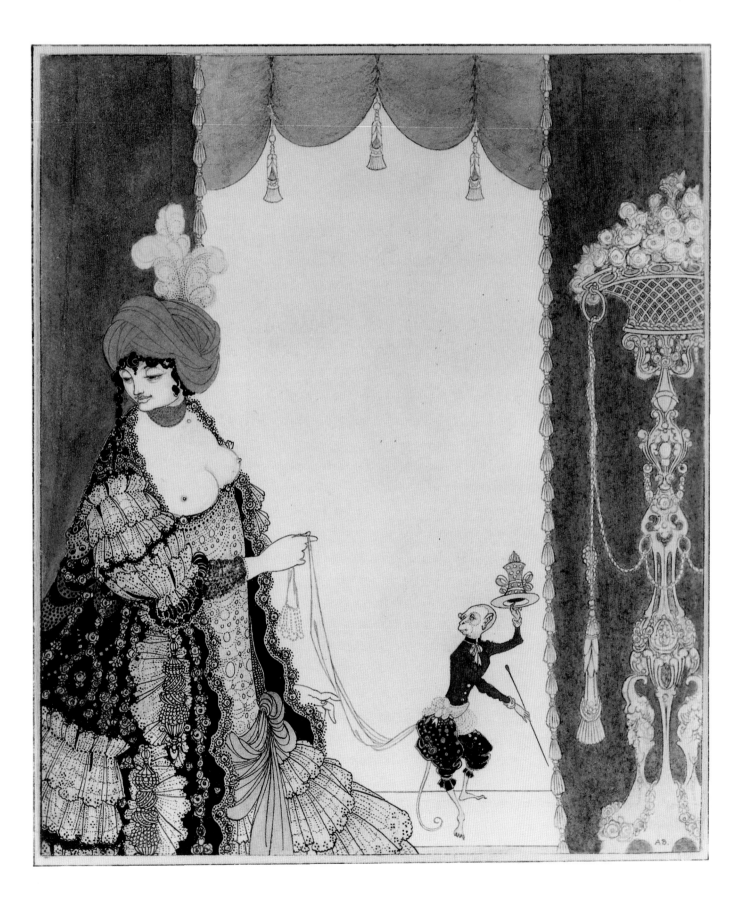

The last known photograph of Aubrey Beardsley, taken in his rooms at the Hôtel Cosmopolitain at Menton. The influence of Mantegna, another master of line, was with him to the end, as may be seen from the montage on the wall.

complained, 'immediately convinced me that he will never do it... It is impossible to get any connected work out of him of any kind.'

At the beginning of September, the Dieppe weather took a turn for the worse, and Beardsley's health deteriorated with it. Mabel told Blanche that the local doctor 'pronounces – but I'd rather not write the word.' Aubrey and his mother returned to Paris, 'sorry to leave... the charming place'. He tried to think of the impending winter 'as bravely as possible, and encourage myself with the recital of "if winter comes can spring be far behind?"' Nevertheless the doctors were still saying that their patient was over the worst: he might 'not only have several years... but perhaps even a long life.'

Not a long life. Throughout October he seemed better again, and was trying to settle down to work for Smithers. Having managed three full-page drawings for *Mademoiselle de Maupin*, only a few weeks later, he had gone off the boil, wondering whether it was possible to illustrate the book without being either 'insufficient or indecent'. Instead, he asked Smithers for another, smaller project which would be less taxing. They fixed on Ben Jonson's play *Volpone*.

In November, 'utterly wretched again, with only the ghost of hope to keep me going', the issue of where he would spend the winter became more pressing, and

The Town of Menton *by Laurent Gsell. 'But for the occasional funeral there would be no life in the place,' Aubrey once said. (The Bridgeman Art Library / Gavin Graham Gallery)*

Menton was again decided on, at least as an interim measure before continuing further south. Ellen and Aubrey left Paris on the eighteenth, their journey complicated by another haemorrhage on the train which left him 'nearly dead'. Despite this, Beardsley remained bright enough to joke that it might have been a 'punishment for taking Gibbon to read', rather than one of Raffalovich's 'pi' books.

Menton was 'less loathsome than I expected'. 'Gay and amusing', there were enough foreigners and non-invalids to relieve the tedium of convalescence, and knowing that his end was near at hand, Beardsley threw himself into work with an almost obsessive dedication, working for three or four hours a day on his new book.

Aubrey's ideas for Jonson's *Volpone* had started out modestly, but as the weeks passed, the project grew in his mind until it came to represent the summit of his achievement: it would put the crown on his life and art. The twenty-four drawings he intended were by far

Decorated 'S' for Ben Jonson's Volpone. *The drawings were executed in a completely new, tonal manner, and had he lived, Aubrey would have had plenty of new artistic avenues to explore.*

the most ambitious scheme he had ever countenanced, and one which, even if had he been well, he would have been hard-pressed to complete.

In the event, he was only able to finish two full-page designs, and five decorated initials. This time it was neither boredom nor lassitude that stopped him. On 22 January 1898, Beardsley was prostrated by another series of haemorrhages, news of which he decided to keep quiet from all his friends, passing them off as merely an attack of rheumatism. In fact, they marked the beginning of his last illness. After the twenty-sixth of the month, he never left his room again.

Throughout February, he continued to tell no one, not even Mabel, how ill he really was, but on 6 March Aubrey suffered an attack of blood-spitting so serious that it was no longer possible to deny the gravity of his case. The tuberculosis had touched an artery in the lung. On the seventh, he wrote a final letter to Smithers and Pollitt, begging them to destroy, 'by all that is holy *all* obscene drawings', signing himself 'in my death agony, AUBREY BEARDSLEY'. Just twenty-five years old, he would write no more.

Mabel, who had been wired as soon as it was clear that Aubrey was beyond hope of recovery, arrived just in time to say farewell to her brother, who died in grace early on the morning of 16 March. We may give the last words to Ellen Beardsley, Aubrey's devoted mother.

Of those last sad days I cannot bear to write, save just to say that his marvellous patience and courage amid very great sufferings from frequent severe haemorrhages and the agony of breathing touched all who were near him to the heart. Morphia had frequently to be administered and at last he passed away, I thank God, while under the influence of it, without suffering the last agony of all, suffocation under an attack, which the doctor momentarily feared. He had won the love of all who knew him in Menton, every waiter and servant in the hotel was absolutely devoted to him, and the proprietor and his wife loved him as if he had been their own. They told me over and over again that he was 'a benediction in the house' and at the last I found in them both the tenderest care and support. They did everything for me and together with the good priest, who also loved my darling tenderly, arranged the last sad rites. We had a Solemn Requiem Mass in the Cathedral and then under a blue cloudless sky the solemn procession (for nearly all in the hotel followed) mounted the hill to the lovely cemetery, in very truth a Via Dolorosa, *and then he was laid to rest in just such a lovely spot as he would have chosen. Dear beautiful soul 'of whom the world was not worthy'!*

Jesus is our
Lord & Judge Mentor

Dear Friend
 I implore you to
destroy all copies of Lysistrata
& bad drawings. Show this
to Pollitt & conjure him
to do same
that is holy
By all
 all obscene drawings
Aubrey Beardsley,
In my death agony.

Beardsley's last letter to Leonard Smithers. Although written in
Aubrey's own hand, the envelope
was addressed by his mother, which may have led Smithers
to believe that it had been dictated to the dying artist.

EPILOGUE

FOR 'THE LOVE OF ALL WHO KNEW HIM'

News of Beardsley's death was met with a flurry of obituaries, few of which predicted that the memory of this extraordinary artist would be long preserved. Over the next few months, however, his friends organised a concerted critical campaign to buttress his reputation, while both Smithers and John Lane brought out new collections of Beardsley's drawings. Although he was never forgotten, it was not until the late 1960s that Beardsley's reputation fully recovered its rightful position; today it stands higher than it ever has.

Leonard Smithers did not destroy Beardsley's *obscenia*. We should not blame him for disobeying Aubrey's death-bed wish, for he assumed that the artist, who had never once in health shown the slightest remorse for the freedom of his pictures, was not in his right mind when he made the plea. He published *Volpone* in 1898, and continued to issue Beardsleiana, licit and illicit, despite being declared bankrupt in 1900, until his death. His end hastened by habitual abuse of alcohol and chloral, Smithers died in 1907. Not one of the former friends, to whom Smithers had always been the epitome of open-handed generosity, attended the funeral of this remarkable man.

The Yellow Book survived *The Savoy* by four months, and folded through lack of interest in 1897. John Lane's 1899 edition of *The Early Work of Aubrey Beardsley*

was augmented when he purchased the copyrights to most of Smithers's Beardsley drawings, and in 1901 he issued a bowdlerized *Later Work* companion, in which the *Lysistrata* drawings were printed but heavily censored. These volumes, reprinted in 1911 without the earlier censorship, did much to sustain and secure Beardsley's reputation.

Ellen Beardsley was condemned to survive her entire family. Vincent died, cared for by her, in 1909; Mabel finally succumbed to a protracted and painful cancer in 1916. Ellen herself, supported by a small Civil List pension and the intermittent generosity of her son's friends, lived on until 1932.

John Rothenstein, director of The Tate Gallery, unveiling the Blue Plaque at 114 Cambridge Street, Pimlico, London, in 1948. (Hulton Getty)

INDEX